SIN SOMBRAS
WITHOUT SHADOWS

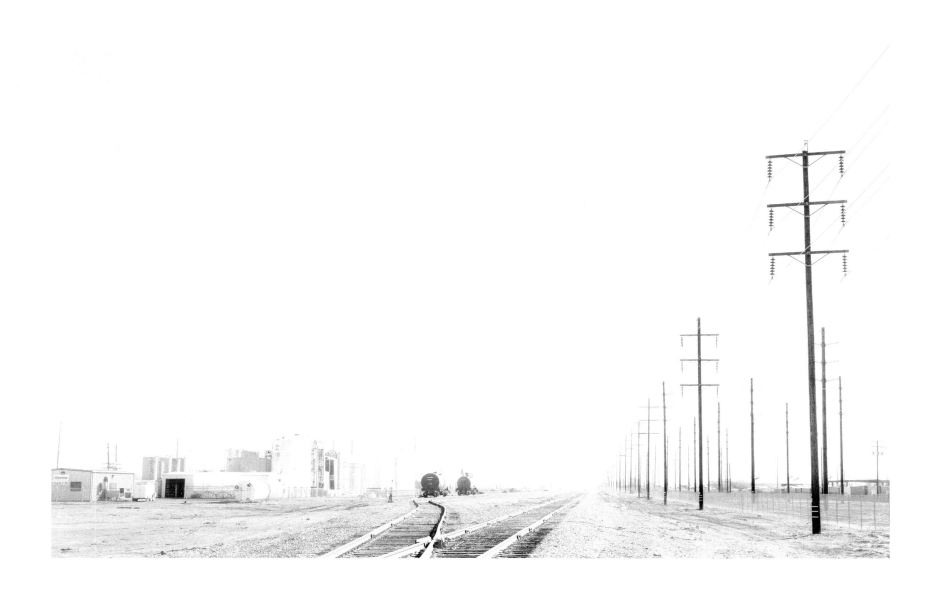

SIN SOMBRAS
WITHOUT SHADOWS

A Search for the Meaning of Life,
if There Is One,
in the California Desert
in Photographs and Stories

BY JAMES G. BARBEE
WITH A FOREWORD BY JACK LEUSTIG

GEORGE F. THOMPSON PUBLISHING

CONTENTS

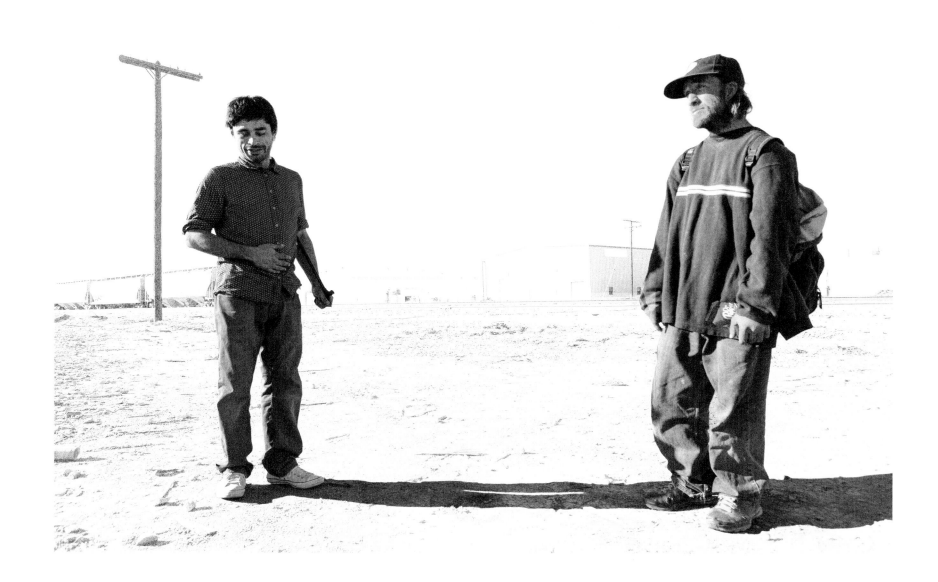

Late in the summer of 2013, James Barbee came into my studio with a portfolio of his photographs on a digital-storage device. Before I opened the portfolio, it was just another normal day. Photographers from all over the country find their way to my studio high in the Rocky Mountains north of Taos, New Mexico. Most of the photographers my staff and I work with, whether they are pros or serious amateurs, come to us because of our skills at preparing images for printing. If a photographer's vision is of beauty, we will make it more beautiful. If it's pastoral, we will make it more serene. In many cases, we will see some potential for the development of a photographer's work that has eluded their skill level. Invariably, once we have done our work, a photographer will tell us that we have realized what he or she hoped was there. The work is enjoyable and rewarding, even if the process can be a bit redundant. This day would be different.

When I clicked on Jim Barbee's folder and began to go through his images, I knew instantly that I was looking at visionary work. His photographs were not about beauty or serenity; they were not looking for placement above fireplaces and couches. In fact, Barbee's images were the antithesis of my normal client's work. Rather than providing comfort, they were charged with longing and loneliness, desperation and defiance, joy and anger. They demanded attention, and once the two of us organized the images into logical collections, the body of work coalesced into a stunning documentation of our time.

I have thought at length about what separates Barbee's work from that of other chroniclers of life and conclude that it is his deeply felt empathy for the human condition. If one looks at the United States as a global fabric that we are all a part of, Barbee goes to the frayed and tattered edges to see who we are. And when we see a grandmother (page 45) or the desolate landscape where she lives, we see contemporary America and its people. They may live on the ragged edge, but they feel like you and me. And although we may think of societies' edges as frightening and distant, when we see the world Barbee has captured—in bright light, without shadows—we know we are connected. In that world, life may be distilled to survival, but that does not lessen the experience of being alive; if anything, it brings the fundamentals of land and life to the surface where we can see them more clearly, in their essentials. Just step out on the edge, and you will find what Barbee captures: the indomitable will of the human spirit.

From a technical point of view, Barbee's photography is well composed and often captures significant moments, but his post-production use of light and color is where his genius is revealed.

He sculpts the images with light and infuses elements with pushed color to control the focus of the image. To my eye, he captures his impression of reality much as Vincent Van Gogh did with paint. The reality is heightened to a more complex place where a grandmother, instead of looking vulnerable, is given power in her humble place. Instead of rendering landscapes as being simply about space, the bleached environments that Barbee depicts foretell an ominous underbelly.

What elevates Barbee's work beyond the many brilliant photographers who chronicle our life and times is a focus that is much broader than the usual images of a selected people or place. Barbee is more anthropological, and that is why this book, hopefully the first of many, may well be historically significant. In fact, when I try to relate Barbee's work to other photographers, I can find no better historical parallel than Edward Curtis rendering land and life among the Indian nations during the late-nineteenth and early-twentieth centuries. Both artists ventured deep to the edges to capture a period of time and culture using the tools and places of their times.

I feel privileged to be an intermediary in the career of this visionary artist. I believe that the early-twenty-first century will be seen as a threshold transition in American culture and world history. I also believe that *Sin Sombras/Without Shadows* will one day be seen as one of the great chronicles of American land and life in the twenty-first century.

INTRODUCTION

"Seeking what is true is not seeking what is desirable."

—Albert Camus, *The Myth of Sisyphus and Other Essays*

So what's the point?

As I write these words, I am sitting on an airplane bound from New Orleans for Las Vegas on a Friday afternoon, no less. The liquor is flowing, people are laughing and singing—Alisha, whoever she may be, just got a rousing chorus of Happy Birthday from a batch of her newly found, very inebriated friends, and the mood is joyous. Anyone here want to look at pictures from a god-forsaken patch of the California Desert, paired with stories about topics such as awe, wonder, longing, mistakes, and death? No way.

I am certain there will be those who pick up this book, take one glance at it, and conclude, "Who needs this?" But for those of you willing to hang in there and give me a chance, what is my aim? The photographs were taken on a series of trips into the California Desert, but they are not about the desert. They are about what it means to be human, as revealed so starkly in this most extreme of environments where, due to the lack of rain, there is almost no vegetation. It is the earth laid bare and our existence in it, much like a cadaver whose skin has been flayed away so that the secrets of its being are revealed. But the people and places depicted herein are not to be regarded like exotic specimens in some travel magazine—they are Everyman and, as such, are no different than ourselves, despite where they happen to live. The stories were inspired by that same theme and hopefully amplify it through the tools provided by another medium. Why do I care so much, as I hope you do?

My fascination with this topic has a beginning, one stretching far back to another place and time—the world of my childhood. No surprise there. The events of those childhood years dog all of us through the remainder of our days, much as does our own shadow. Perhaps it is the peculiar lack of substance of each that lends them their perfect tenacity.

I grew up working in my father's sawmill, beginning about the age of four. Don't worry, this wasn't child abuse, for in my earliest years, I was playing at work for the most part. We were living in small-town southern Mississippi during the 1950s—and all that went with it. Many of the men were illiterate and signed their name for their paycheck with an "X." They had very few teeth, and I doubt they could have mustered a full set among them. The summers were deliriously hot; in winter, the wind bit hard enough that, on some days, it could make a man's eyes water.

In the years since that time, I have been fortunate enough to become a physician and, in the course of doing so, have had the chance to associate with some of the best and brightest.

Comparing my two worlds, I am impressed that they were not all that different. Some people are honest, others habitually lie; there are people who work hard no matter what they're getting paid, and those who are lazy or feel entitled without cause; some people are blessed to be cheerful no matter what happens to them, and then there are those who never find cheer in anything whatsoever.

The world where I grew up still fascinates me, and the experiences remain vivid, for my mind was young and fresh. I saw how hard the people at the sawmill worked and what little respect they got. I realized early on that life can be harsh, even cruel, and is not always fair, and I learned the degree to which luck—both good and bad—can determine our destiny. To pretend otherwise is nothing more than hubris—an indulgence made possible by one's good fortune.

I understand now that this childhood world of mine has been endlessly repeated, including that to be found in the California Desert, where I have photographed since the 1980s. These are places, as I have heard it said, where one doesn't bleed in the water, as it attracts sharks. In such worlds, one must be tough, resourceful, and self-reliant, whether one's purpose is good or bad, 'cause the cavalry sure as hell ain't comin' to the rescue.

Most of the images presented in Sin Sombras were taken within 30 miles on either side of a line drawn between the gritty little towns of El Centro, south of the Salton Sea, and Barstow to the north, a distance of roughly 200 miles as the buzzard flies. All of them were made during the past five years or so. In most places, the evidence of man is relatively scant—a few small towns and some highways and farms scattered about here and there, haphazardly, as if they had been set in their places by the careless instincts of the desert wind. Some of the structures are fresh out of the box, so to speak, such as the garish outlet malls along the interstate exits, while others amount to little more than abandoned ruins, decaying in the sun, as might be said for some of the people who live here.

Mostly, there's a whole lot of nothing. It is a world without clutter, in the extreme.

As a result, one can always see the horizon—all 360 degrees of it—upon which rests the dome that is 180 degrees of sky. The world set beneath that dome is largely naked rock, other than those places covered with sand or altered in some way by the activities of the dominant species here—man. Frequently, the skies are cloudless, and as there is virtually no humidity to scatter the light, it settles on the landscape, unadulterated, as perfect as the moment it left the sun.

Oh, and there is the wind that engenders a sense of restless agitation except at twilight, when the air often becomes very still and liquid, providing a medium such that the spirits might wheel. That wind coats all of the earth that is not moving in a patina of fine, white dust that, in turn, reflects the light upward, back to the sky from where it came. In this world, the light washes over you from all directions, such that one is immersed in it, as there is no cover, no merciful shade.

In this space one can grow blinded, overwhelmed—

suspended in the substance,

become light,

as if one might dissolve,

between heaven and earth.

For without shadows—*sin sombras*—there is no place to hide.

The desert is a harsh, even brutal setting, as it is not merely indifferent, but actively hostile to one's survival. It is a furnace, set to incinerate the superfluous, those who are idle, spiritually weak, or feckless. This is a place to take a hard look at yourself. As we are flawed and imperfect, are we not all in need of such reflection? Herein lies a legacy of the desert that stretches all the way back into biblical times—a book which, after all, was written by people roaming around in . . . what else?—the desert. Even in these media-besotted modern times, the desert offers itself as an ancient, hallowed retreat into solitude, a laboratory of unflinching self-examination. And where does one begin such an inner journey? It is only when we acknowledge how very small we are that we may surrender ourselves to unrestrained wonder . . . reverence—an awareness of the majesty that is Creation. It was in another desert (the Big Bend region of West Texas) where I first sensed the Music Universalis (Music of the Spheres), as I observed the motion of the moon, planets, and stars, each welling up in the absolute void of space above me, made visible by an un-cluttered, twilight sky. This is the world into which holy men, mystics, and, yes, more than a few "crazy" folk have ventured for thousands of years, seeking Vision from the vision uniquely created by the conditions to be found there.

As for the seven stories that conclude the book, they were largely written back home in New Or-leans. Given how much I have traveled and how intensely I wanted to get out of the Deep South as soon as I could after graduation from high school, it seems ironic that I now live only about 100 miles from the world in which I grew up. I had a friend in a similar situation who summed up his journey by saying, "I guess that I haven't come very far in life." That seems to pretty much be my story as well.

Although inspired by the California Desert, much of the content in the essays I have found walking in the woods here or staring into the depths of a Louisiana pond, where I spend many hours swimming for the exercise, back and forth like a metronome in the dark, murky, oak–stained waters, for the most part unable to see the bottom or what is lurking beneath me. When the sun is shining, shafts of light scintillate within the water, enveloping me, then disappearing soundlessly into the depths below. It is as if I am suspended on the surface, weightless, flying above the abyss. Without effort, thoughts begin coming to me, like some sort of possession or visitation. For this reason, I am left wondering if this small body of water has magical powers, at least for me.

It is the belief of some native peoples that bodies of water serve as a portal between our world and that of the spirits of those who have lived and died and of those as yet unborn. I like to think that, when I am immersed in the waters of this land, the spirits are passing back and forth through me. When my mind is uncluttered, a few of them leave a faint trace and are given sub-stance in words. I liken the process to the science of physics, where one studies the vapor trails of subatomic particles as evidence of their existence.

The photographs and stories are meant to explore what it means to be human—within this complex topic, there are discernible recurring themes. The first is the belief that great wisdom and beauty can be found in the everyday, throwaway moments in life that we often do not value until threatened with their loss through life events such as losing a job, becoming ill, or experiencing the death of someone close to us. A second is the inspiration to be found in the "invisible" people in our lives, the everyday, anonymous folk wandering along our roads, pouring coffee into our waiting cups, cleaning up our messes. These are people just trying to make a living, get by. Few of us pay much attention to them or particularly care whether they fail or not, live or die. I see nobility in the acceptance of their anonymity, for the most part without complaint. Finally, there

is the riddle of human consciousness: How do we live gracefully with the knowledge of our certain death? How do we accept that we are so vulnerable—that our lives can be profoundly altered or even vanish in an instant, as if we are of no more weight than smoke?

Without exception, no matter how grand or seemingly empty the landscape of the California Desert that may be depicted in the photographs, if you look hard enough, you can always detect some trace of human activity. This evidence is strewn across the face of the desert like so many clues to the solution of a great riddle-mystery for which we are not smart enough even to know the question, much less the answer, being laid before us. But we can be certain that such marks proclaim, "Hey, I . . . *was*. . . walking here!" (to paraphrase Dustin Hoffman's character in *Midnight Cowboy*) for all eternity.

How can I justify blurring the boundaries in the stories between fact and fiction? Does anyone imagine that images taken with a camera do no less? Whether immersed in desert or pond, pictures or words, the world of the California Desert depicted in the pages that follow dwells in the twilight between "fantasy" and "reality." This terrain is that of Inner Space, of our imagination, where the rules are different—in fact, here there are no rules. We will become like Dorothy in *The Wizard of Oz*, sliding back and forth across the threshold that divides the comforting certainty that is her Kansas home from the dream world that is Oz. If combining fiction and nonfiction seems "genre-bending," is not the process of human perception just as flawed? And so we exist with an imperfect tool (the mind) in perpetual uncertainty—just what did it all mean? Why am I here? Where is the Creator?

There are far more questions than answers to life, yet I am strangely/deeply content, wrapped as I am in my mystical cloak of awe. Not enough of an answer for you, conditioned as you are by notions of "God" all wrapped up in administrative matters of right and wrong, paternal compassion, the Big Plan for your life? I am left to conclude that these are best seen as the concerns of humanity, for, as a physician, I need look no further than the pervasiveness of chaos, as exemplified by the casual wrecking ball that is disease, to conclude otherwise. I am of no more or less significance other than the degree to which I am *witness*—and, in this way, awareness and particularly the creative process are acts of worship. This awareness is what binds my fear so completely that, when it's all working right, that fear enhances the experience of it all, setting my senses on fire. William Blake, are you out there somewhere, listening?

Yes, awe is the answer that allows a sense of wonder about Life to expand. And I believe I might well be disappointed by any other answer, rather like finding out that the Wizard behind the curtain is nothing more than a befuddled old magician. My experience of awe is put forth in the photographs and stories in these pages.

SIN SOMBRAS
WITHOUT SHADOWS

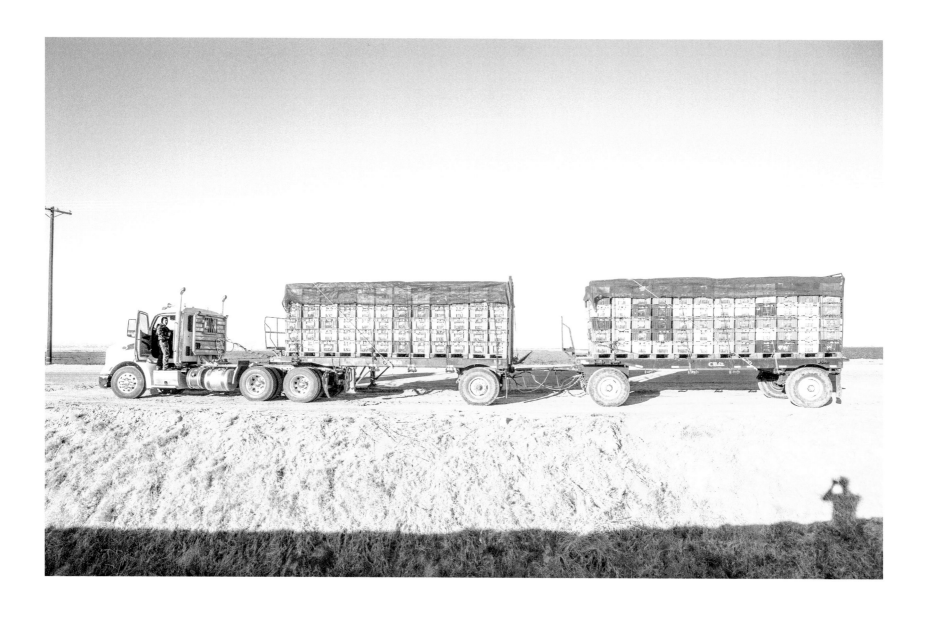

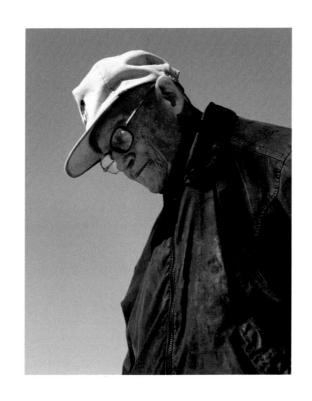

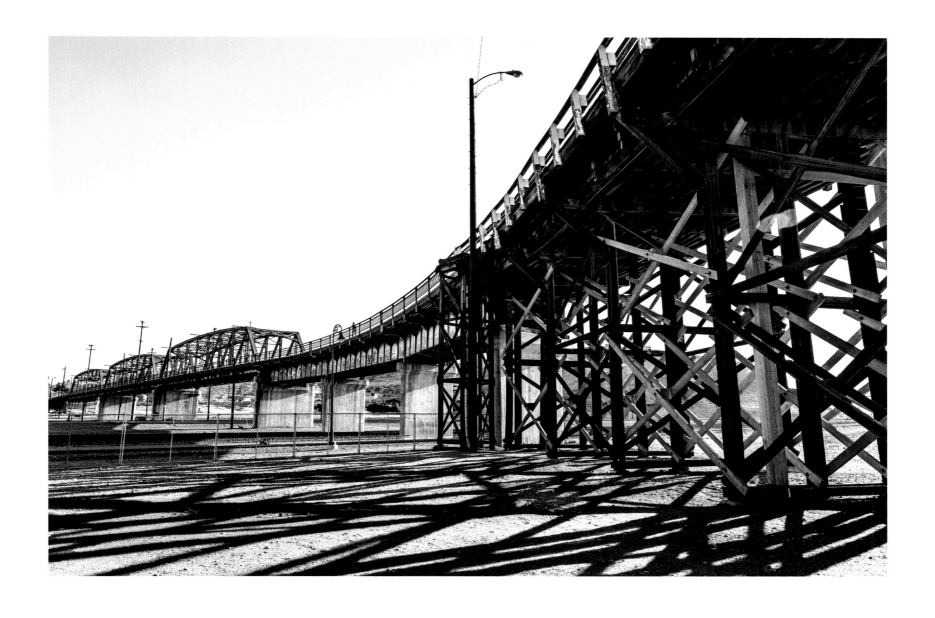

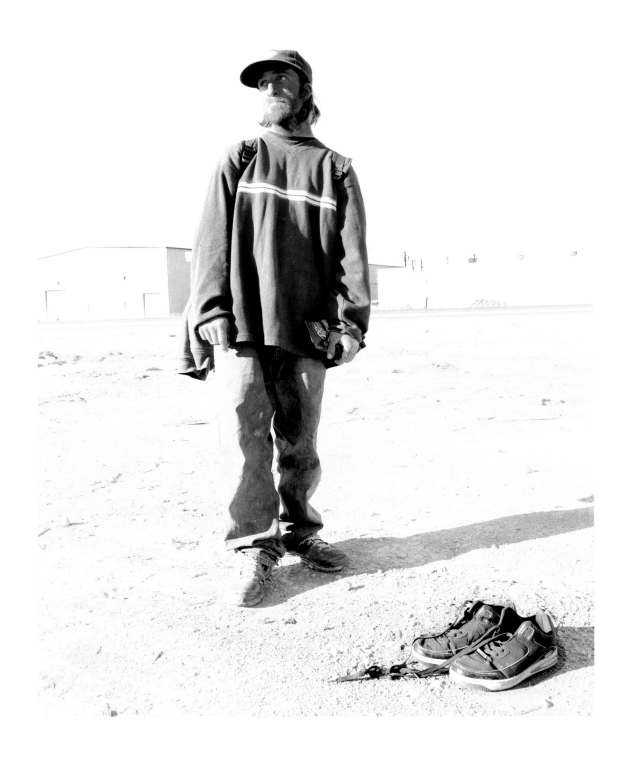

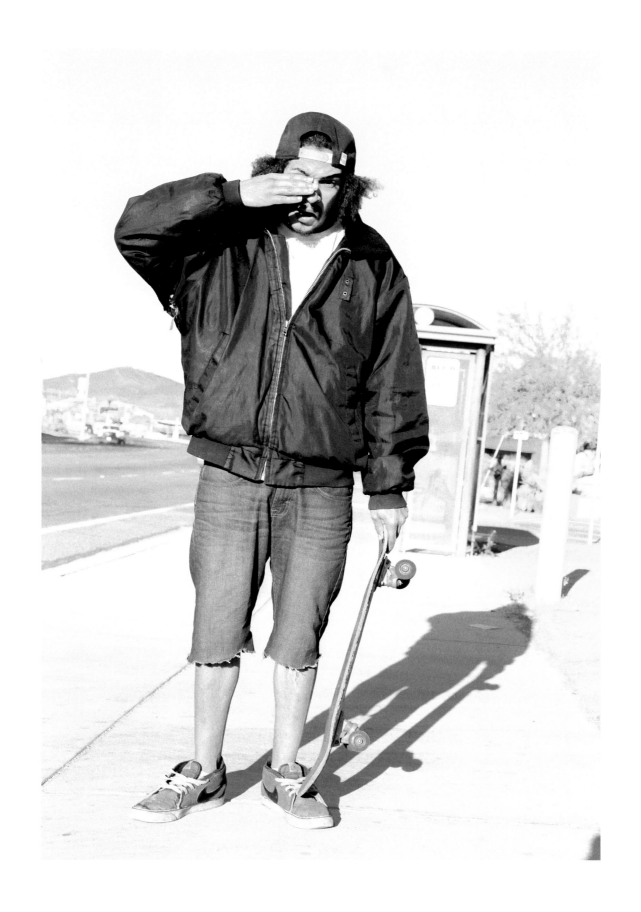

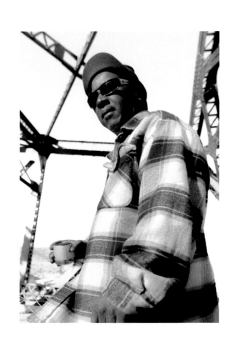

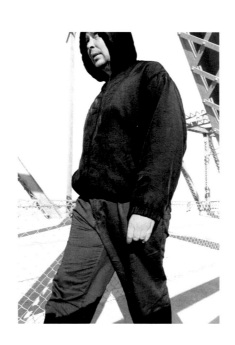

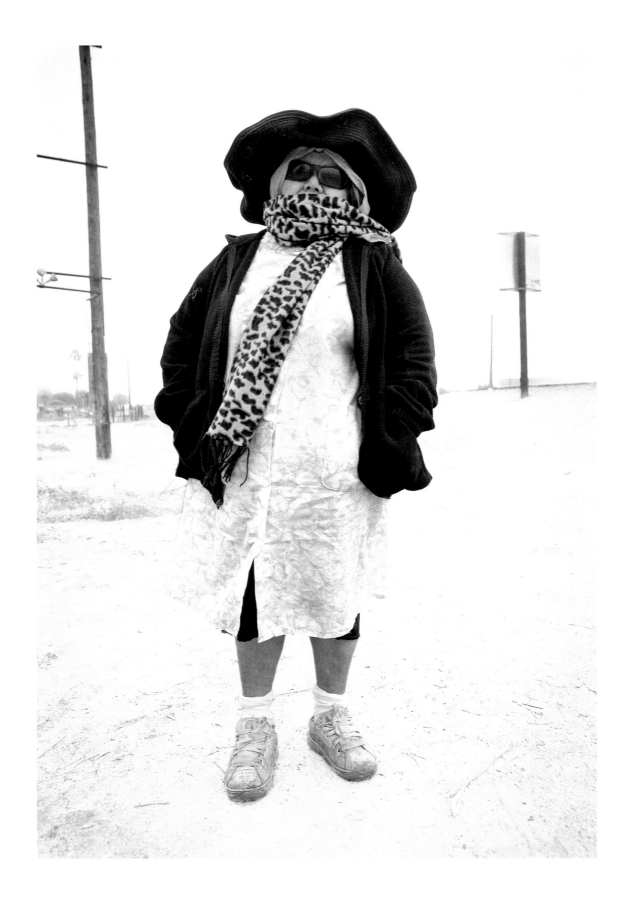

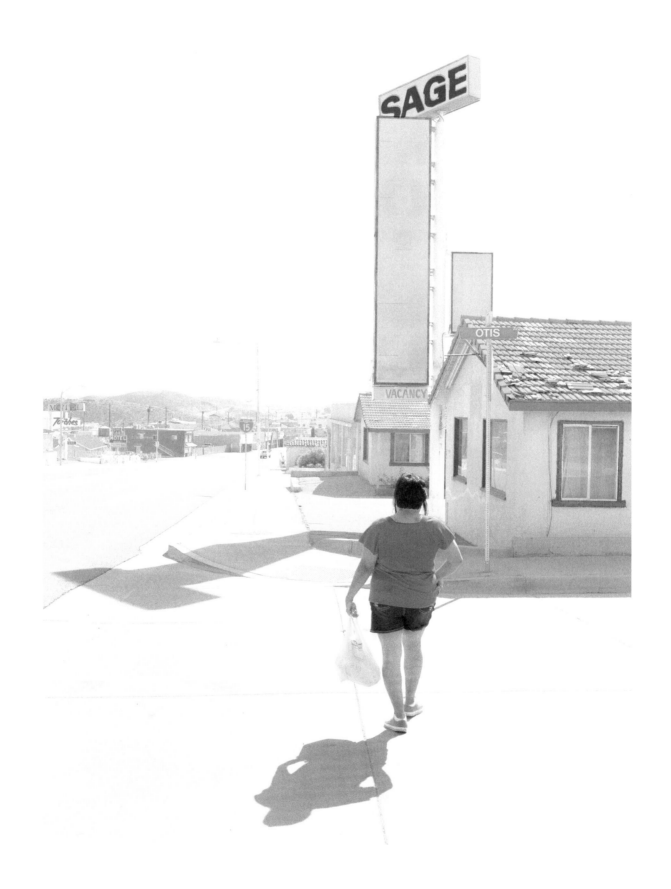

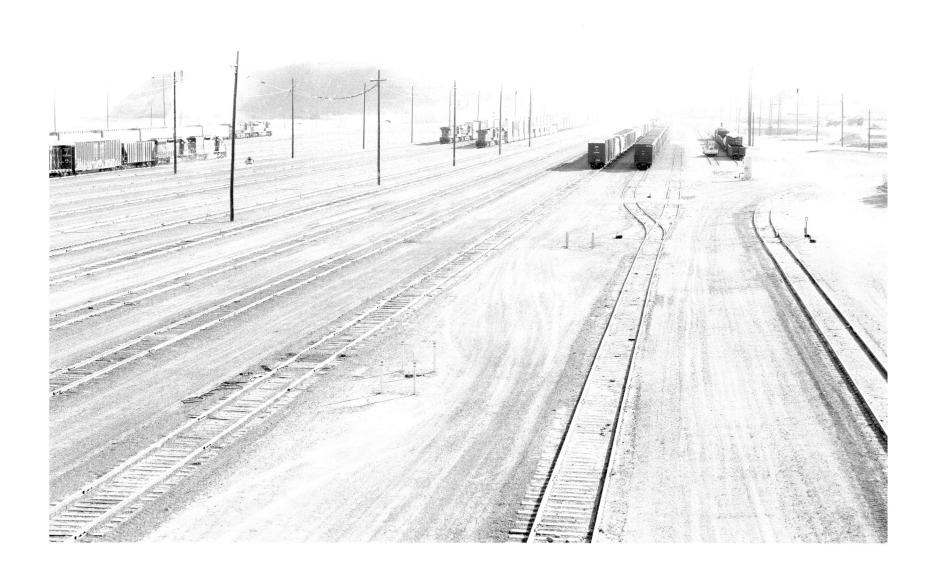

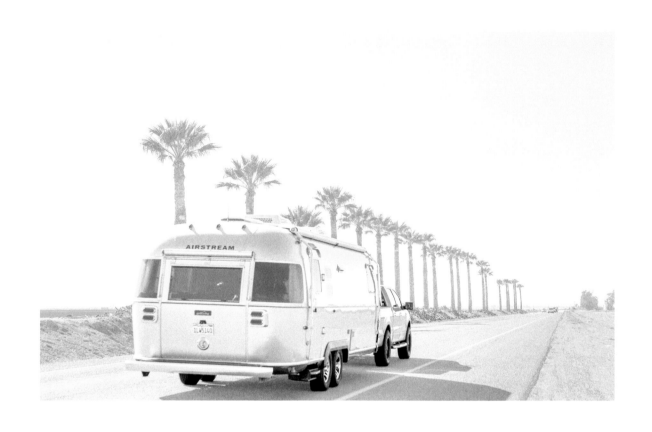

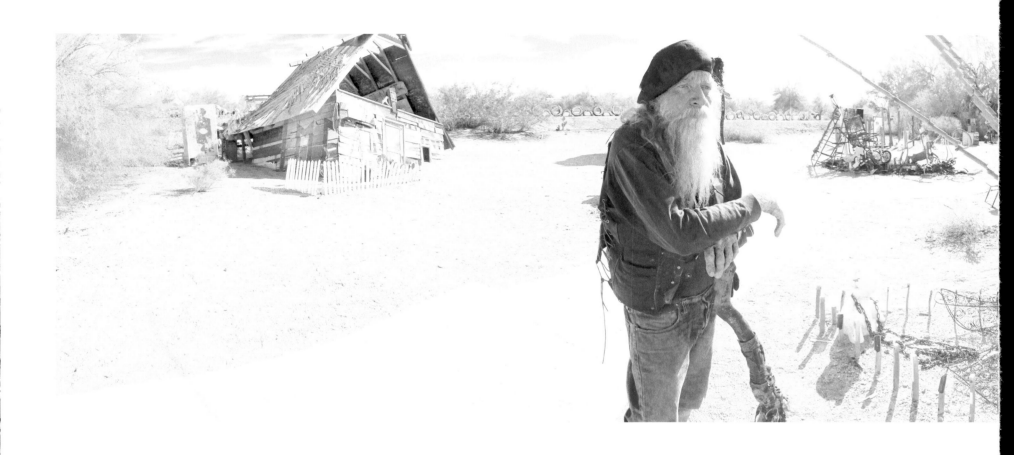

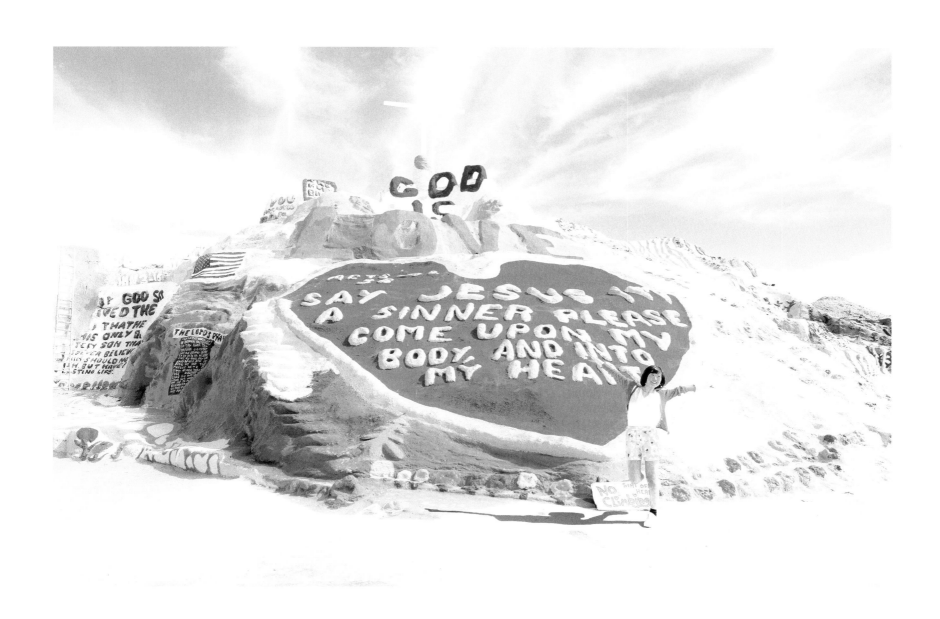

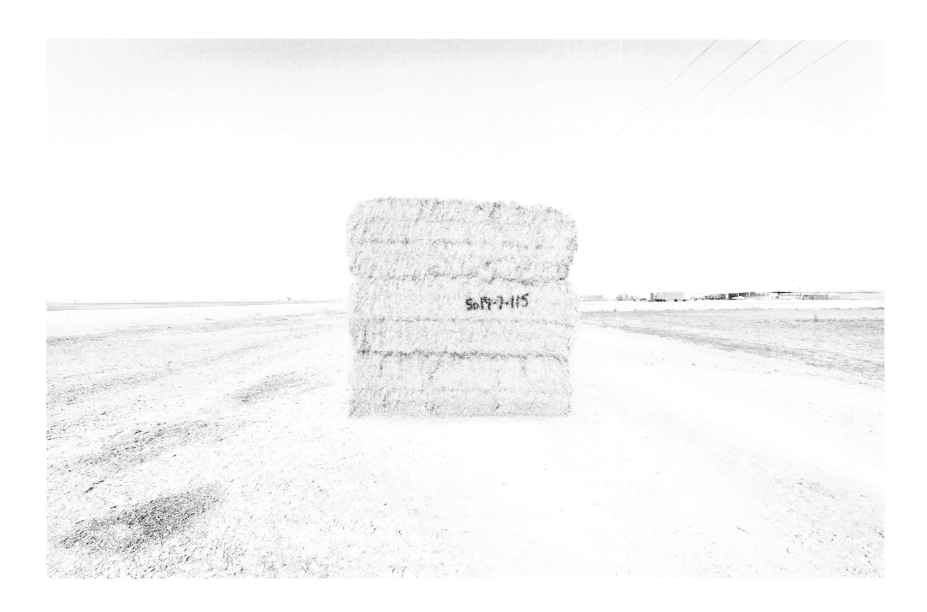

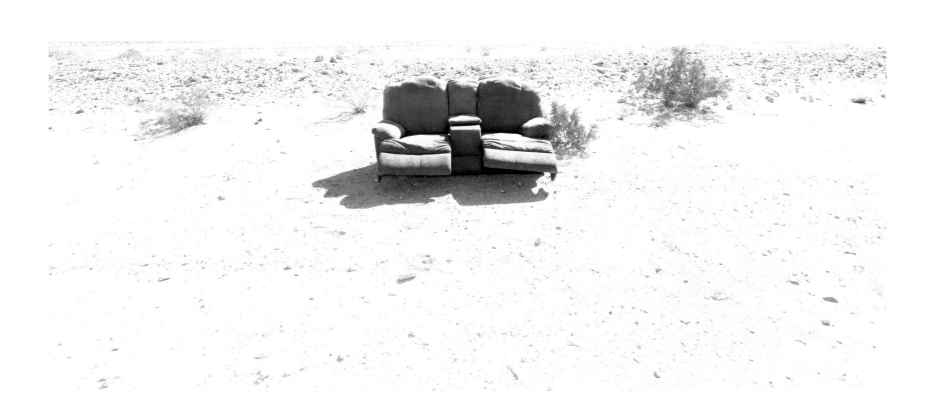

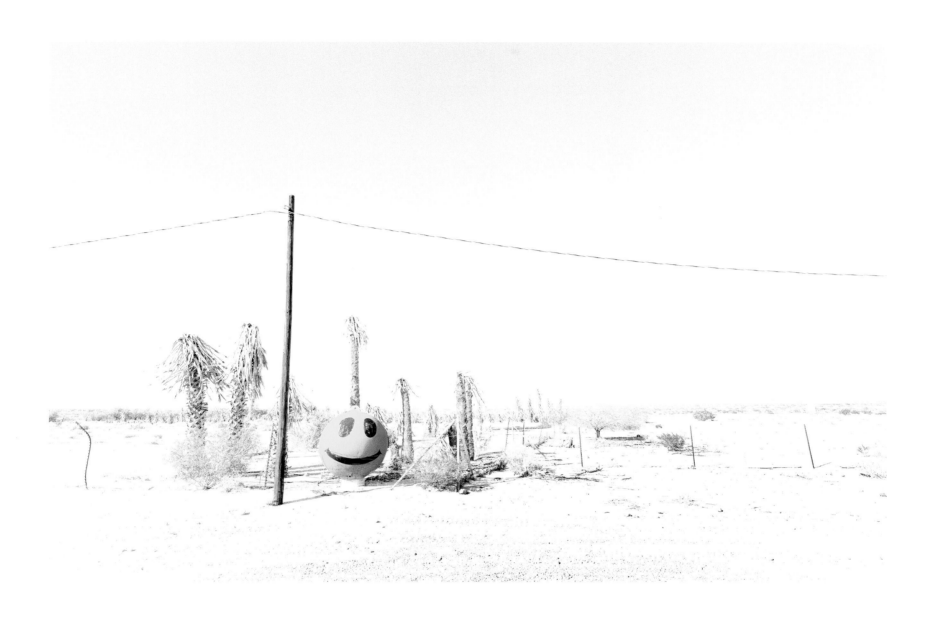

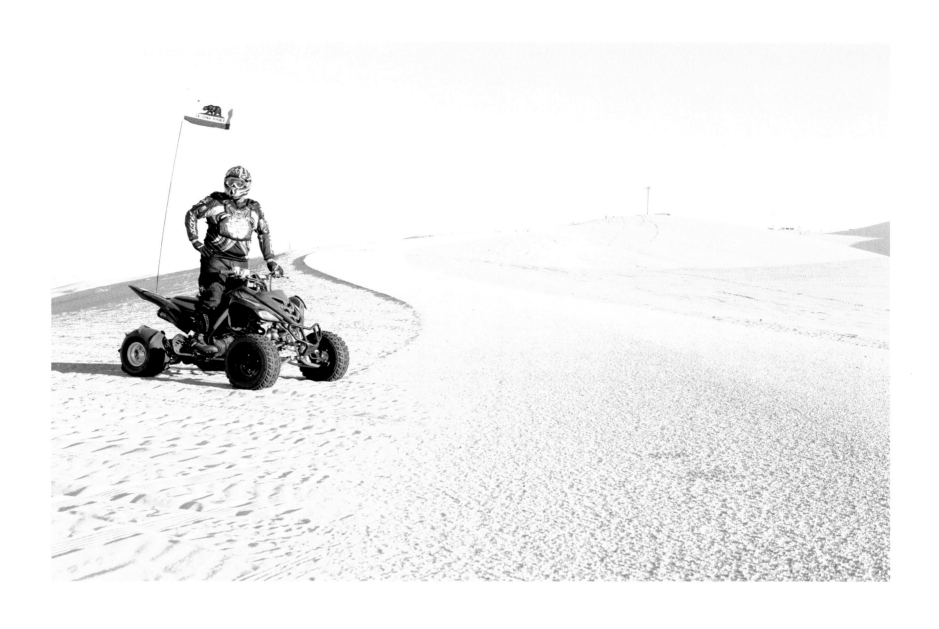

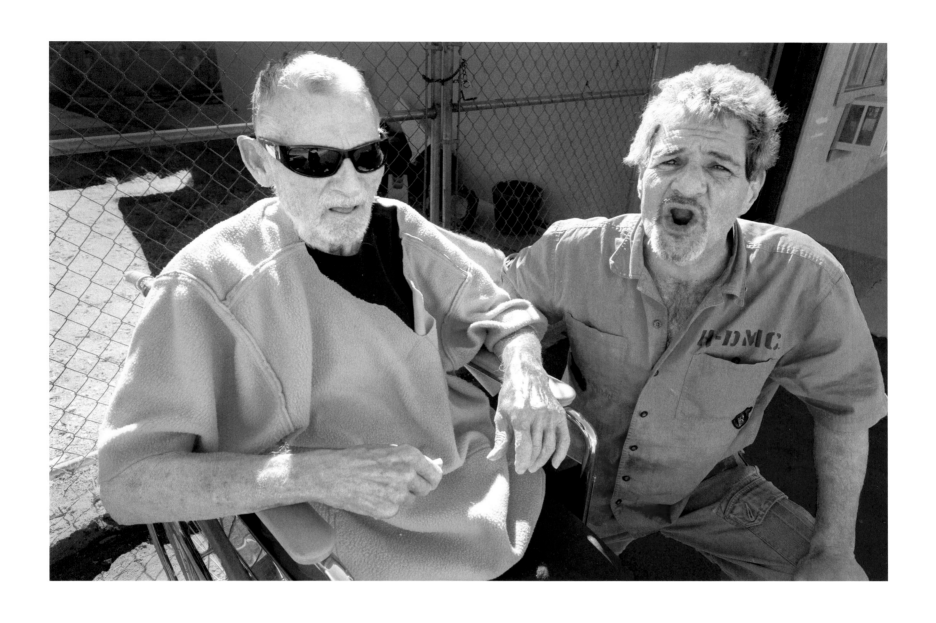

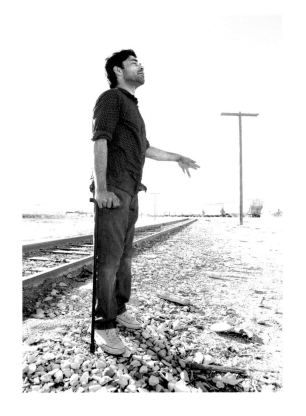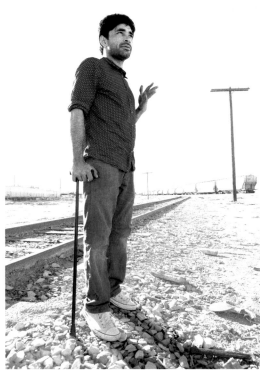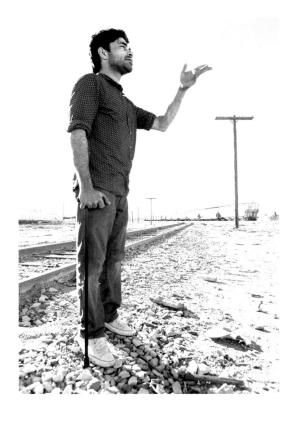

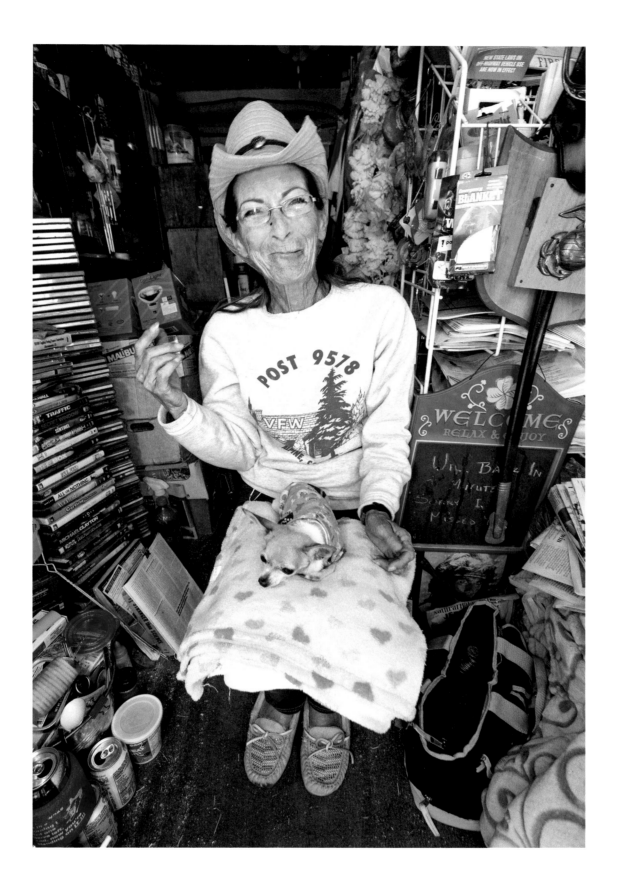

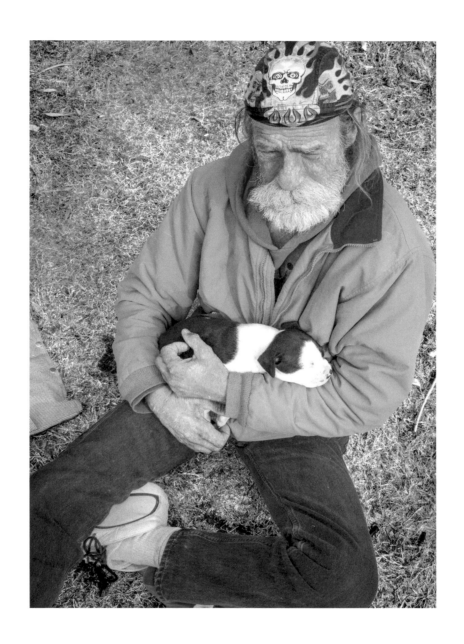

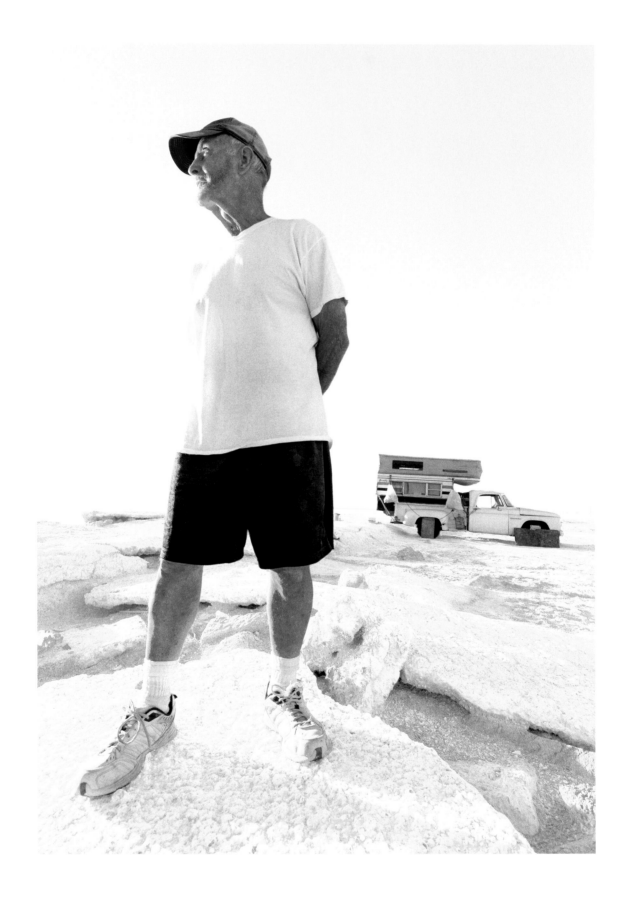

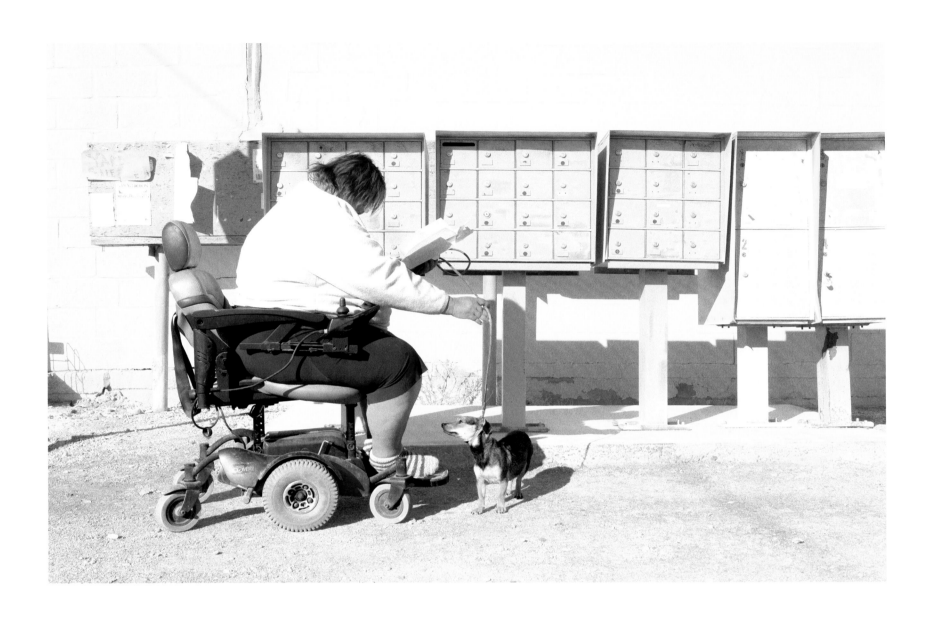

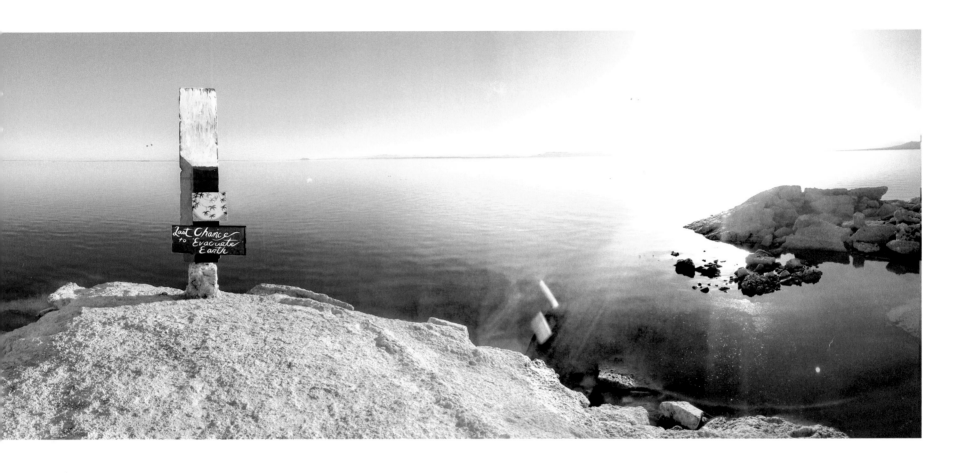

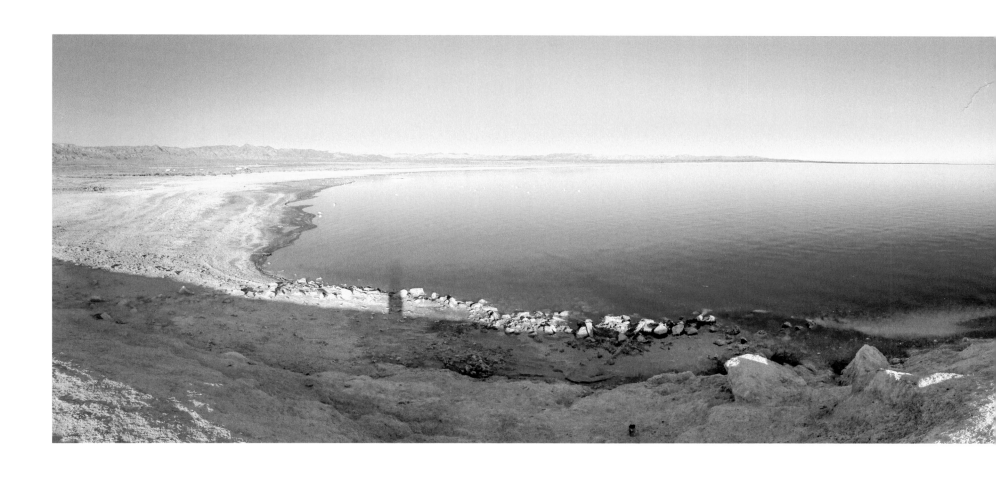

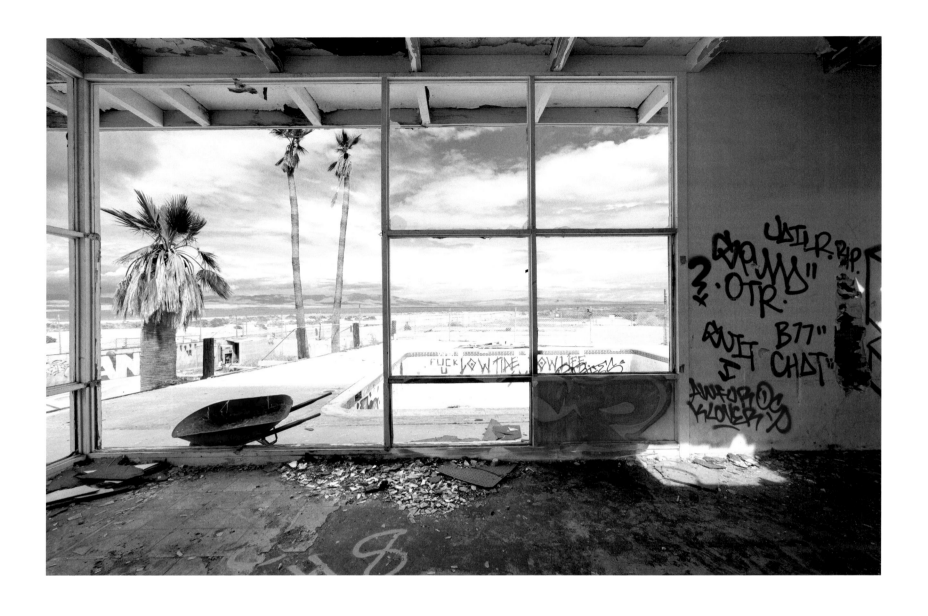

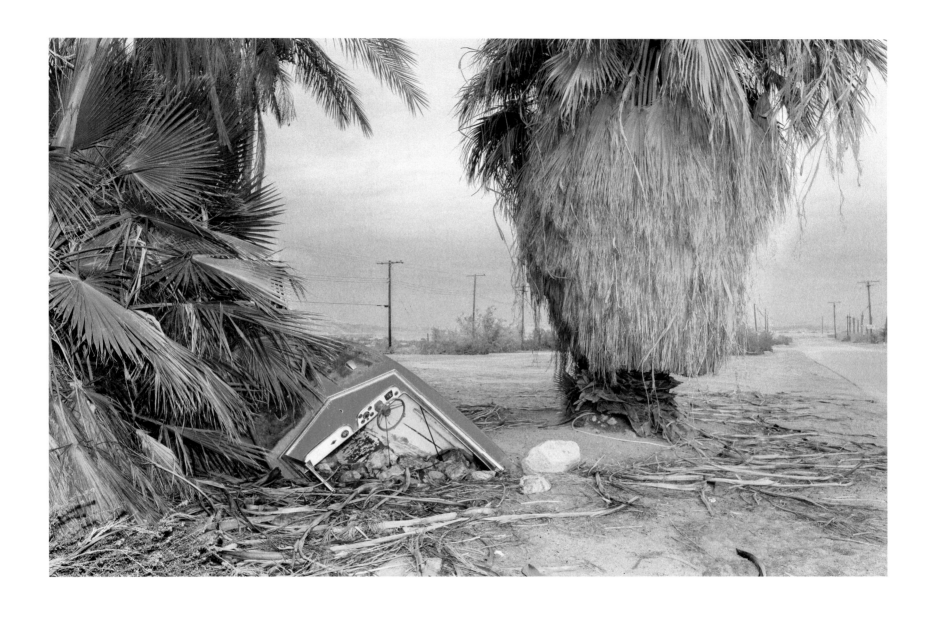

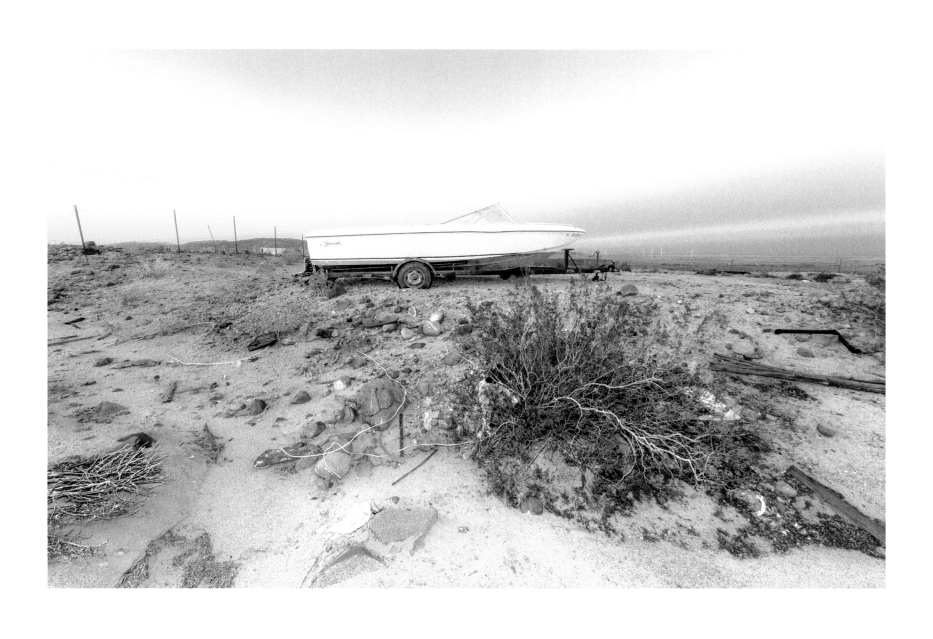

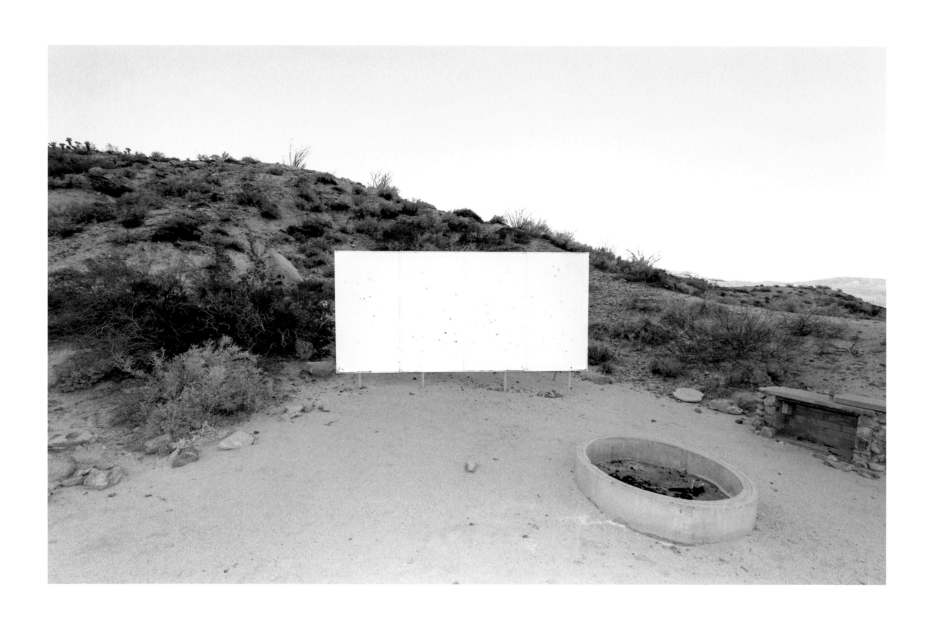

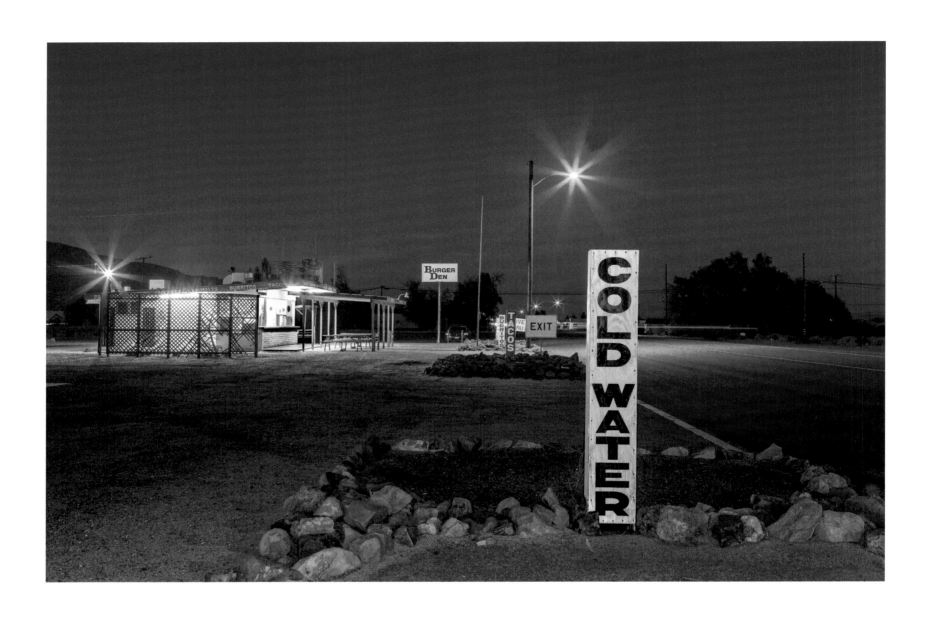

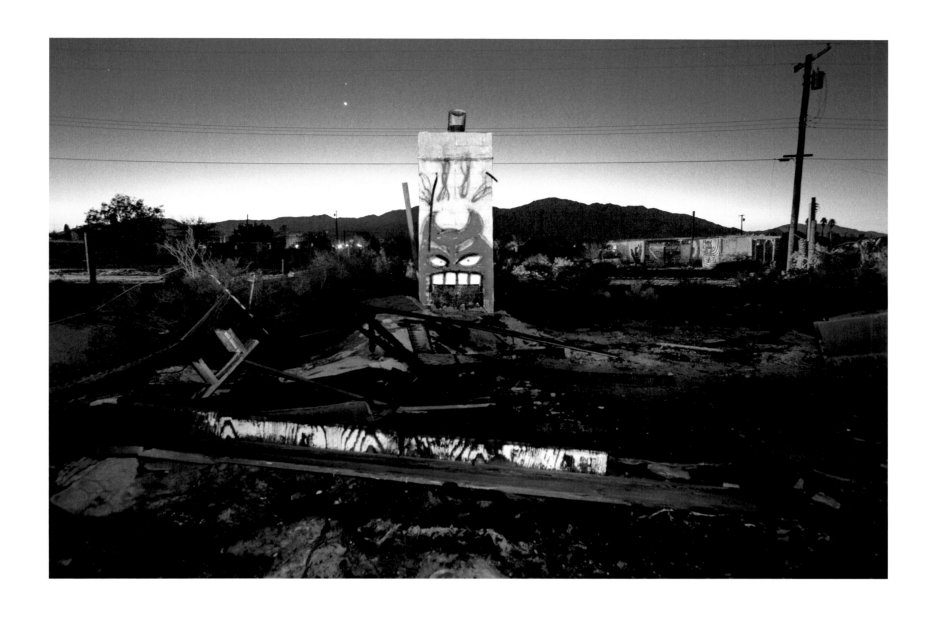

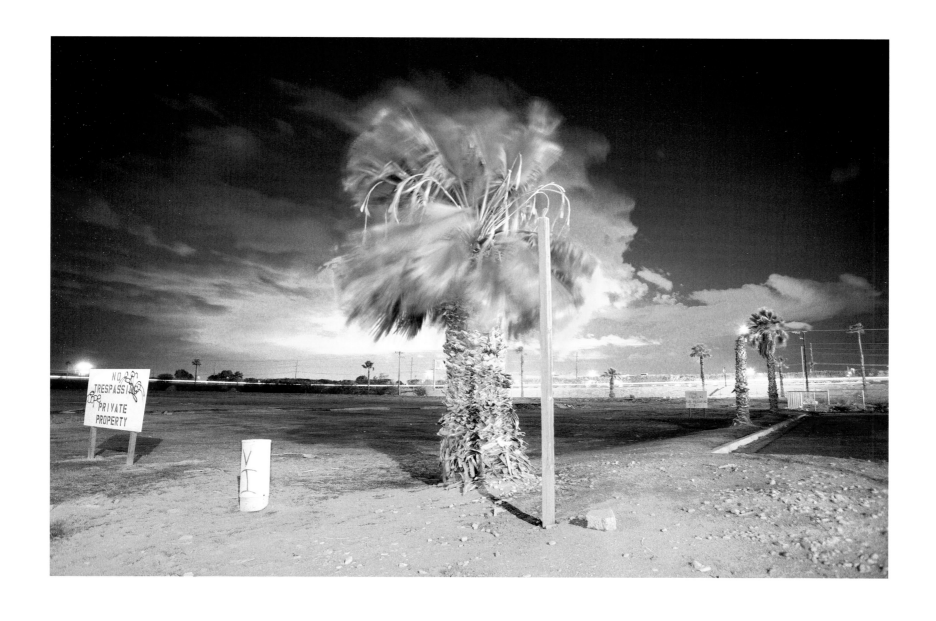

LIGHT, SHADOW, AND AWE

"The Mystery of mysteries is the Door of all essence."
—Lao Tzu

This story was inspired by three photographs that explore the properties of light. The first, *Sin Sombras,* was taken at high noon on a cloudless day in a vast, virtually featureless field stretching in all directions. Despite the illusion of clarity, the image conceals much. When this is understood, it is rendered cryptic, perhaps even threatening in its beguiling, superficial candor. For what the viewer cannot discern is that my back was tightly pressed against a second, enormous stack of hay behind me so that I could frame the image. Or just how far back that stack of hay in front of us extends—it stretched for nearly 50 yards. What may lie in wait behind it? In reality, there was nothing, but, for the sheer pleasure of it, let us imagine that there was a thief with a very sharp knife, waiting to pounce upon us. Kind of fun, isn't it?

And then there is the ability of light to create drama. As seen in the second image, *2 HR PARKING*, the woman in the picture has been transformed by a shaft of light from a tourist in rumpled clothing to an object of fascination—an actress upon an impromptu stage. She was a stranger, her back turned to me. We did not speak, and I am uncertain if she was even aware of me. I had no idea from where she had traveled to arrive at this very spot or where she would be going from here. I knew nothing of her being—be she angel or devil, saint or sinner. It is eerie to think that this encounter, set upon a vast, heaving sea of sand, was likely the only time we will ever see each other in our lives.

As for the third image, *Blank Screen, Anza Borrego Desert,* we once again view a facade as in *Sin Sombras.* Yet here we are confronted with an object that not only conceals that which lies behind it, but, by design, actively reflects upon the viewer whatever is projected upon it. Anyone you know? Can we not agree that, often in relationships, it is difficult to know the difference?

One of the common ways to define a desert is to suggest it is a place with an awful lot of nothing. As a result, few shadows are to be found, for nothing is there to cast them. Shadows require substance and are, therefore, proof of existence—including our own. Perhaps the experience of death is to awaken and find that one no longer casts a shadow.

What are the mysterious phenomena we call light and shadow? A shadow is created when rays of light are blocked. It is often in the absence of something or someone that we can best understand our experience of their presence. One might use the understanding of shadow much like a hungry oysterman inserts the blade of a knife into the clinched shell of his prey, prying and twisting the knife with all his might against great resistance, in the hope that his labors will be rewarded with the possession of the tender, morsel-prize concealed within.

First, let us acknowledge that, like many things in this world illuminated by the sun, shadows are everywhere (except in the desert or the ocean—an interesting paradox) and, thus, easy to take for granted. Unless you are a small child. I was walking with my then one-and-a-half-year-old daughter one morning, teaching her to throw rocks at a fence. Please do not assume that I was nudging her along into a life of crime, as the rocks were very small—I promise. She kept pointing excitedly at the ground in front of us in obvious fascination. I saw nothing worth such interest, until it dawned on me that she was looking at the shadow of the fence where it lay, prostrate, before us. She related to it as if it were a palpable object with a presence and density of its own—not merely a veil of absence lain across the carefully manicured lawn grass.

I have never seen shadows in the same way since. Okay, I can't say that with a straight face . . . I mean how often are we *aware* that we are *not aware* and should be. (Hmmm, *awareness about awareness*, isn't that aware[2], so typical of consciousness?) How easily we slip back into numbness, taking the world as it has been set before us for granted. Maintaining one's sense of awe at the levels merited by the world in which we have been placed is a challenge—is it not?—when we spend so much of our time consumed by the demands of everyday life.

In that moment, my daughter reawakened in me the awe of the natural phenomenon that we call "light," both its presence and absence. Of all of the many wonders of the Universe, it seems to me that just two are the most mysterious of all: light and time. Light is a "particle" (called a photon) that avoids commitment (like many of us), stubbornly retaining properties of both matter and energy—but more on this later. Time is the great, sucking undertow in which the Universe has been seized. It is all the more mysterious, as it cannot be detected by our senses. It is also frightening, because it inexorably drags all of creation in but one direction— the EXIT, be you a leopard frog, a galaxy, or a human being. Why, even the pantheon of modern divinity—athletes, politicians, and movie stars (yes, even Elvis)—must live without exception under its rule!

The great wisdom of all of this preordained death and programmed destruction is that the EXIT is necessary for reinvention. "Out with the old, in with the new" seems to be the *modus operandi* of existence. In this way, are we not made of the same stuff as the Universe? A coincidence, do you think? Not so, say the Taoist sages from centuries past. But I digress.

Both we and the Universe are perpetual malcontents, uneasy with whatever state we find ourselves at any one moment. Nietzsche wryly summed up this principle in *Twilight of the Idols*, in which he wrote, "Man does *not* strive for happiness; only the Englishman does." (Hitler would later use this quote as a justification for the superiority of German culture. Clearly, the humor was lost on Adolf; yet another example of the caprice of fortune as well as the fact that paranoid, narcissistic people can't take a joke).

So *time* is the essential grease for the machinery of change, and time is Master of all, save . . .

Light!

This was a principle deduced by Einstein, who entwined light and time (not athletes, politicians, or movie stars, although this has been known to happen), conceiving of them as much like two furiously writhing snakes locked in an all-encompassing embrace for eternity, such that one is not functionally complete without the other. For it has been ordained that the speed of light is the "superglue" of the Universe and must remain a constant—which is no small feat, when everything in this Universe is careening about at great velocity, in multiple directions, simultaneously. Since speed is based upon the outcome of distance covered in time, one need only *continuously* tweak the denominator (time) in *every* corner of the Universe at the *same instant* for all *eternity* to make it all work out! I mean, damn, Who invented this stuff!? How's that for magic? All I can say is:

Actually, I can't say *that* because it is in Japanese, which I do not speak. It is the Japanese word for "inexplicable awe"; but even when a Japanese person can say the word, they are acknowledging that awe at this level of understanding (or lack thereof) is impossible for anyone to wrap their mind around. Is this God? If not, is it not the reification of God—whatever "God" is, or isn't, for those atheists who are by now rolling their eyes? But for those of you who remain certain that there is no God, what does a deity need to do to get some respect? Maybe God is not dead, because "God" was never "alive" in the simple way that we understand life and death. Take that, Nietzsche!

But back to the fence. Fellow travelers, do you not find it wondrous that light birthed 8.33 minutes ago, in the furious nuclear holocaust that is our sun, can travel across 93,000,000 miles of nothing just to be laid so soundlessly, effortlessly at our feet? And in mind-boggling quantities that defy comprehension—approximately 10^{17} (that's a little less than a billion billions) protons per second per square centimeter. Applause, anyone? With entertainment like that, who needs talk shows to kill time?

Now, let's step away from the fence and examine a subject of endless fascination—ourselves. As noted, we are engines of dissatisfaction, if for no other reason than we are endlessly caught between our animal drives to eat, reproduce, and dominate that lie in uneasy juxtaposition within us, embedded with such altruistic instincts as love, loyalty, and self-sacrifice. Is it not a wonderful property of our nature that one of the best ways of achieving happiness and the relief of our own suffering is that of relieving the suffering of others? And yet we fail and become riddled with our inner shadows—thereby embracing the absence of the radiance that is our better selves. As in the physical world, such psychic shadows are imbued with both the power to offer the cover of darkness and, at the same time, to conceal a threat. We, as individuals, segue back and forth within this duality, often living uneasily in the awareness of its existence. Much like light and time, are we humans not just as mysterious?

As for light, light imbues openness and transparency—that's good, right? And yet is not that which is transparent without substance? As every painter and photographer knows, it is the shadows that give a composition its dimensionality, thereby creating the illusion of depth.

Still, the inner pain of our remorse is no illusion—it is our teacher or at least can be, if it does not destroy us from within. For inner darkness has properties much like those of acid and fire. When present in the right balance and handled with utmost care by a learned mind, their properties can be embraced and exploited, often to great benefit. Even so, it is easy to lose control . . .

Yet when we find ourselves in a place, *sin sombras*, where there are no shadows, there is always much left unseen. For we are aware of only what lies in the direction in which we are looking, oblivious to whatever is happening at our backs, much less in the place—and this world—where we live. Even blessed with perfect vision, our awareness would be limited to that which lies between the horizon and us, for Earth is not flat, but curved.

And there is the reality that, even in the places where we are looking, our perception penetrates no deeper than the membrane that is the surface of any object or landscape wherever we gaze. And so we exist never truly knowing what lies beneath that facade or, for that matter, what lies hidden at any given distance behind it. Because Einstein also deduced that, for small beings like us, unlike massive objects such as the stars, light travels immutably in a straight line, indifferent to both our existence and fear of the unknown.

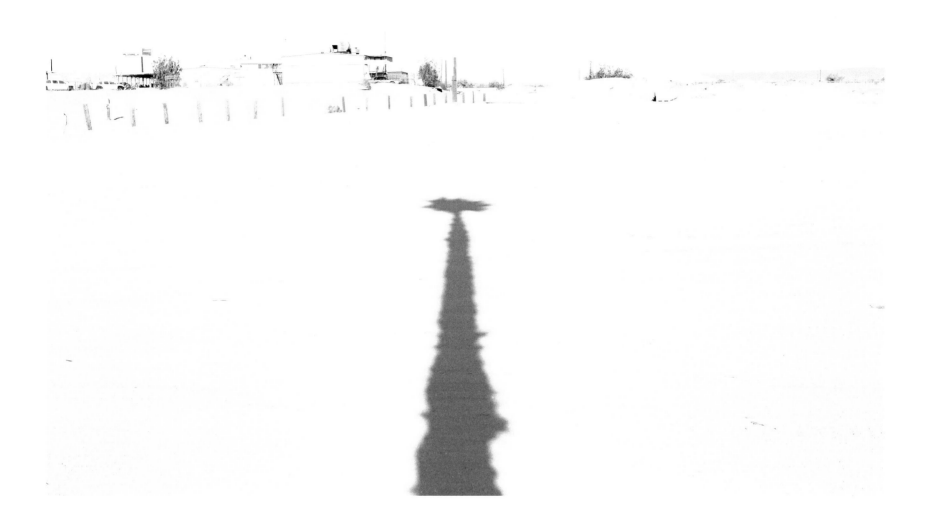

WISE BY MISTAKE(S)

"Hell, that's why they make erasers."
 —Clarence Darrow

When looking at the world, one senses that we have arrived at a threshold. There is not only the threat posed by biological and nuclear weapons, but the risk that we will significantly "foul the nest" of our small planet, the one place in the Universe we can call home. It is our crib—the only one we've got. Our capacity to transform the planet radically on so large a scale, however, is a relatively recent phenomenon. Living in New Orleans, I only have to travel an hour or two to witness the alteration and outright disappearance of land along the Gulf Coast of the United States occurring through a combination of rising ocean levels, subsidence due to oil and gas development, and the diversion of the Mississippi River for shipping and flood protection.

There are other examples of our penchant for "rearranging the furniture" of our planet. One need look no further than the Salton Sea, a massive engineering blunder created in the California Desert more than a century ago. The images entitled *Last Chance to Evacuate* and *Low Tide, Low Life* convey, for me, the uneasiness I feel around the Salton Sea, which doesn't belong there and looks it. Perhaps that place has a special poignancy for me, since my life was upended by Hurricane Katrina in 2005. Although the storm was a natural phenomenon, the events that culminated in the flooding of New Orleans and the tragic loss of so many lives were the product of the colossal mistakes of man and our casual indifference to the impact of our activities upon the little spaceship that can sustain us—planet Earth. Are we worthy of such power?

"Dad, there are no mistakes."

These were the words of my now twenty-year-old daughter when she summed up her experience of "doing time" as an adolescent. She went on to say that even the adversity she had experienced was valuable in shaping who she had become—a hard-won testimonial of the principle that "what doesn't kill you makes you stronger." As we strolled down Eleonore Street in the immediate aftermath of a midsummer afternoon thunderstorm that is one of the many experiences that I treasure in this little world-bubble called New Orleans, I wondered if it is true. Are there no mistakes?

One of the best places to explore this question in the starkest terms is some 2,000 miles away, in the middle of the California Desert at the Salton Sea, a place very unlike New Orleans that, on average, gets a grand total of three inches of rain per year. To put that in perspective, that's about the depth of a cup of coffee. In a year.

The sea is a 343-square-mile *oops* of epic proportions, the product of the activities of a group of engineers and developers determined to bend an entire landscape to their will. Their bright idea was to divert the Colorado River over many miles of desolate landscape to this area via a system of canals. Whereas before there had been only expanses of drifting sand, with the opening of the Imperial Canal in 1901 vast tracts of rich, now-productive farmland appeared. Add water and, *voila*, instant paradise!

So how did this lead to the formation of California's largest "freshwater" lake? It was the result of something that no one foresaw (the *mistake*): Heavy rains and snow run-off in 1905 caused massive amounts of water to flow down the Colorado River. The river, which by virtue of all that engineering had become little more than a docile servant, was now enraged—think Nature on the rampage here, as in King Kong, bellowing at the world from his new-found roost on top of the Empire State Building. The structures that had disciplined the river were destroyed, and, uncontained, the floodwaters, instead of racing southward to the Gulf of California along the natural course of the river, sought their way to the west, as if lost, to the site of the modern Salton Sea. After a period of 18 months, the engineers were able to wrestle the Colorado temporarily back into its restraints by building new dams and canals. The problem was not decisively fixed until 1930, when the massive Hoover Dam was completed. So how does the construction of a 6,600,000-ton dam strike you as a fulfillment of the "dominion mandate" some have discerned in *The Holy Bible* from Genesis?

The world that Man hath created here is a quirky place. Indeed, it is a bit surreal, rich with irony and paradox, yielding scenes that are, by turns, ludicrous and sublime. The sea offers a glimpse of human power gone awry. It is how the world might appear if, in a moment of weakness, our darker angels ever prevail, and we nuke ourselves out of existence. And yet it is also a wonderful place to observe the remarkable adaptive ability of those people and creatures who came here to stay in this incredibly hostile environment that, at times, can look more like the surface of Mars than of Earth. The Salton Sea thus serves as an armature to explore the rich complexity created by the mistakes that each of us inevitably makes in our own lives. It is a place where people came seeking profit and power by growing money on those vast farms or, at the other end of the spectrum, simply looking for a little privacy—a great place to hide. What better location for an Elephant Graveyard for aging Hippies? (You'll have to find it yourself; the location of elephant graveyards is always kept secret.)

Let's begin by filling you in on enough details so you can "see" the sea. For starters, statistics regarding the size of the lake, its depth, and surface elevation vary over time and source due to the ever-changing balance between water getting in and water getting out of the basin in which it sits. Such inconsistency hints that the lake may have an identity disorder—never a good thing, at least in humans. But there's no doubt it's way below true sea level (-235 feet as of 2017). As a result, it is a place where water can only drain but never leave (channeling The Eagles here), other than by evaporation.

Walking around the shore, far below sea level, leaves me a bit uneasy, seriously. I think it is because, in my youth, I watched too many times as Pharaoh's Army got annihilated when Charlton Heston, as Moses in *The Ten Commandments,* decided he had had enough and commanded the waters of the Red Sea to close, settling the ruckus—permanently. (I am certain I identify with the unredeemed.) Yet despite being far below "sea level," the Salton Sea is, depending on the year, only about 43 feet deep at its lowest point. This seems counterintuitive when you're already on the bottom of the ocean for much of the planet. I guess "Non Sequitur Sea" doesn't have much of a

ring to it and is hard to spell, even if it's conceptually more satisfying, but remember those quotes around "freshwater?" The waters of the Salton Sea are actually 25 percent saltier than seawater—enough that, when conditions are right, boats can actually travel more quickly here by virtue of being able to plane higher on the denser water. Weird or cool—take your pick.

The area averages 309 days of sunshine annually (a great place to work on your tan), and air temperatures reaching 124 degrees Fahrenheit have been recorded in the Salton Sea area (Ocotillo Wells on June 21, 2017). Due to the extreme conditions, the predominant inhabitant of these waters nowadays is the Mozambique tilapia. They're tough little "wetbacks" from Africa, introduced for "sport fishing," but even they succumb in massive numbers (up to 7,000,000 in one day) when the water conditions turn nasty. This is not a place for sissies.

The sea was marketed by developers as the "Salton Riviera" during the 1950s; from 1958 to 1964, nearly 32,000 residential lots were sold. Unfortunately, the dreams of those who purchased these lots looking for a little piece of paradise were largely doomed (yet another mistake), due to the high salinity of the waters, regular fish kills, and—when the conditions are right—suffocating odors.

Oh, and another messy detail—the sea is vanishing slowly but surely, like some desert mirage. Over the years with few exceptions, the water level has significantly dropped due to a combination of factors, including the demand for water by agriculture and the thirsty, sybaritic denizens of Southern California's ever-growing cities. There is also the lack of rain and ongoing evaporation—no doubt made fierce by the saucepan-like combination of great heat, shallow water and extreme sun exposure. Structures built along the waterfront during the 1950s and 1960s are now high and dry, in many places stranded hundreds of feet from the shore, looking lost and forlorn. There is an abandoned marina with docks set in dry sand, a restaurant with enormous picture windows devoid of any glass, and graffiti—lots and lots of graffiti—creating the impression that, in some areas here, chaos reigns, unrestrained. This is a modern Holy Land, a splendid palimpsest, summing our times—a place fit for pilgrimages. It is post-apocalypse tourism and desert living at their finest.

If all that isn't enough to peak your interest, there is an invisible, sinister presence lurking beneath the placid surface waters, prowling along the bottom of the sea. (Forget King Kong—let us now gather our collective Ouija boards and summon Bruce, the lovable, if taciturn, great white shark in *Jaws*). I am referring here to none other than the San Andreas Fault, created as two great tectonic plates grind over each other. One of these slabs of rock is headed north, the other south—not exactly ships passing in the night, but it's the same concept. Even now, "swarms" of baby quakes occur intermittently, and geologists predict that it is only a matter of time until we experience the Big One. How about that for creating a delicious sense of suspense, foreboding, and inevitable doom?

The Salton Sea as it now exists shows the glorious complexity of the choices we make in our lives. The settlers who came here had to figure out what to do with the "worthless" desert landscape, just as we seek answers to questions such as "What do I want to be when I grow up?" or "Do I eat more fish and less red meat?" This complexity is particularly poignant when we eventually toss the choices we make into the wastebasket labeled "mistakes," based on the outcome. We all know that mistakes are bad—don't we?—and that we should make as few as possible—right?

No!

Okay, that categorical "no" was a bit of an overstatement. What I really mean to say is that mistakes are not all bad. In fact, it can be argued that they are the most powerful driving force

for personal growth and development. Through mistakes—by living—we learn the lessons of life through our own experience, rather than the often-shallow process of merely being taught those same lessons. That is the difference between knowledge and wisdom. It is, perhaps, the reason that, in my experience, there are many smart young people but very few wise ones. After all, do parrots understand the meaning of the sounds they make? Maybe they do, as I have been told that parrots live a long time and are *very* smart, but to whatever degree they do or don't is the difference between knowledge and wisdom.

One way to cope with mistakes when we make them, as well as to pass on wisdom, is through the use of adages. Some are used so often that they risk becoming clichés. I suspect that, even in such cases, they serve a function much like prayer beads whose surfaces are worn smooth with worry and hope over the years.

In order to explore the lessons offered by the Salton Sea, let's start with a classic selection, shall we, like "Nothing is all good or all bad." Okay, the guys who arrived here more than a century ago wanted to tame the desert and make it fit to grow crops—nothing wrong with that. But then, due to ignorance of natural processes and events they could not foresee, the whole thing got terribly screwed up. This is the type of scenario that keeps us awake at night, trying to anticipate we-know-not-what boogey man will leap out at us the next day and catch us unprepared. Know the feeling? Of course, you do.

And there is always a flip side to life: In the process of flooding the landscape, an important stopping point on the flyway for North America's migratory birds has been created. Birds love the Salton Sea—up to 3,000,000 a day sojourn here! And we all love birds—don't we?—even if they are modern dinosaurs, a race of beings that, in the prime of its evolution, ate our ancestors for snacks. And how about those wingless "snowbirds" (I refer here to human tourists) who flock here, particularly in the winter, to escape cold, gray weather back home. They not only get to enjoy being here, but also create jobs in restaurants, motels, and filling stations to support their needs. Isn't this what Manifest Destiny is all about?

But then there are those problems that I alluded to previously. Walk on the "beach" in many places, and you find yourself crunching the bones of legions of dead fish. They were killed during the algae blooms created by fertilizer runoff, as the algae consumes all of the available oxygen in the water. The skulls of the fish (does each of *them* have a soul?) litter the beaches, seemingly locked in frozen screams. Even though the sockets of their eyes are empty, they stare at *me* accusingly. What did I do to deserve such hostility? Is there such a thing as species guilt? Could anyone have seen all of this coming? Of course not, but what has happened here shows that some of the consequences of the choices that were made many years ago were good, some bad. Point made, I hope.

So let's examine another classic lesson. "When life gives you lemons, make lemonade." Pretend you are a fish who must have enough water just to breathe, and you find yourself an egg with a zillion or so of your closest friends conceived in a puddle in the middle of the desert that is steadily drying up. What do you do? Swim around and bitch about the weather? Nah, nobody cares, nobody wants to hear it. Now, you could fantasize that some tourist is going to come along one day and scoop you up, take you back to their comfy home in LA, and stick you in their climate-controlled aquarium. *Not* going to happen! The better course is to learn to enjoy your desert views and content yourself with the knowledge that, if all of your friends get killed in the next die-off, why, there'll be more oxygen left for you! Hope (that you will survive the next cataclysm) is one thing, but fantasy (such as winning the piscine equivalent of the lottery) simply brings discontent. I guess sometimes it is hard to know the difference.

Yet another piece of advice often trotted out in times of adversity is: "It's always darkest before the dawn." You know, the Salton Sea has actually existed five times before—the creation of the caprices of geology and not human engineering—what with those tectonic plates always bumping and grinding along, constantly rearranging the landscape of the region and planet. So cheer up, ye fishes of this dwindling sea, hang on just for another, oh, 50,000,000 years, and maybe the sea will become part of the Gulf of California once more. Then, you, too, can be summering in Cabo San Lucas right there at the tip of Baja, just like all your fellow two-legged California brethren do now!

But honestly, as I grow older, I have become aware of a more sinister twist on the "darkest before the dawn" adage; that is, "It's often darkest before it gets black." Ouch! Who came up with that? Does that mess with your head like it does mine? I will leave that bit of wisdom, like one of the dead fish, for you to contemplate.

And then, of course, there is that great favorite that people resort to when trying to comfort those who have endured great adversity. Even parents often rely on this one when they can't come up with anything that is more creative: "Suffering builds character." Remember all those dead tilapia on the beach, screaming for eternity? I am uncertain to what degree character matters to tilapia. I have concluded from the manner in which fish can maintain their orderly ranks so perfectly in sardine cans that they are disciplined souls. I must here concede that the skeptics among you are thinking, "But they have no choice." Ah, but, according to philosophers, the concept of choice or, as they would frame it, free will is a complex issue, is it not?

Be that as it may, I am certain that character matters very much to most humans. And here we stumble upon a subtle but intriguing complexity of the mistakes issue—for there are "mistakes" that we make as the result of genuine blunders (such as the Salton Sea) and there are those that we make of our own choosing. Such mistakes in this category fall into two groups: those that occur because we are behaving badly for personal gain (good old-fashioned sinning) and those that we make for reasons that are more opaque (to be discussed below).

Let's talk about sinning first, because something in our nature is naturally attracted to this topic. I know, I know, just the word "sinning" has a creepy, old-fashioned ring to it, unfit for these modern times. But, nonetheless, we all behave badly sooner or later, no matter what you call it, and, for the purposes of this discussion, we shall adopt the fierce honesty about oneself to be found in the desert—so let's call a spade a spade, a sin a sin. In this category, we find behaviors such as those outlined in The Ten Commandments: we kill, we commit adultery, we steal, we tell the teacher that the dog ate our homework. Really! God takes this very seriously; I mean we all know what happened to Adam and Eve.

Sadly, we are all wired in such a way that, although we know something is not right, we are tempted, perhaps tormented, even so. At such moments in our lives, we wrestle with our *conscience* . . . whatever the hell that is. Nights are particularly bad for this type of temptation, when our idle minds are free—and to which playground do they stray? Why, the one owned by the Devil! This is the world in which Dr. Faustus dwelled, and look what happened to him!

And back to that "wired" thing . . . who sculpted this blob of fat (that's right, it's 60 percent fat) that we call a brain anyway, and just what purpose does this inner conflict between desire and conscience serve? Modern neuroscience actually offers insights into the biological basis for the conflict. The brain is set up as a "push me-pull you" device for multiple tasks, of which making the choice between right and wrong is but one example. It is ambivalence by design, allowing us to cope with the multiple unforeseeable environments in which we find ourselves. But admiring

it is one thing; living with it is another. Aren't there times when you'd rather have been born as a "pair of ragged claws" (that's T. S. Eliot-speak for a lobster) or, better yet, maybe a Monarch butterfly, so that your toughest choices in life are which flower to land on next? I bet their inner world isn't nearly as complicated as ours.

Be that as it may, I was born human, and I first began to explore this topic of mistakes in earnest when I was about ten years old. I stole a red lollipop from the checkout line at the grocery store. My mother was shopping, the line was empty, and so no one was watching—in short, all of the right ingredients for the perfect crime. I remember taking that lollipop out to our car and sinking low in the seat so that no one would see me. I unwrapped it; I can still smell it, even after all these decades. And you want to know what? I enjoyed it. *For as long as it takes to consume a lollipop.* And I have had to live with the guilt ever since. And so, friends, half a century later, I'm still twisting in the flames of guilt for having taken a five-finger discount on that piece of candy.

Now, I only stole that sucker once and have never stolen since then, because "I learned my lesson" (another tried and true adage, loved by parents). But, unfortunately, there are those bad choices that we keep making *over and over again.* What's that all about? First, let me hasten to note that, even at this level of failure, there are subtle degrees of moral turpitude. After the first time or two indulging in something that you know could be wrong, there is still room for a defense of innocence, naivete—of *exploration.* This can be best summarized by paraphrasing William Blake, who opined that it is hard to know how much is enough of something without having had too much of it. This latter principle was, by the way, one of Blake's *Proverbs of Hell,* which, in this instance, might better be entitled *The Road to Hell.*

In the absence of the defense of youth or inexperience, why do we do bad things, particularly time and time again? There are many reasons: Our desire is too strong, the rewards too sweet, or the consequences insufficiently severe. And so there is infidelity, lying, murder, and theft (including lollipops). This is why we must have a society governed by laws, and, as a practical matter, there must be rules that are created and enforced. One must acknowledge the existence of true Evil and pure Virtue in this world, but is it not important to separate the essential "administrative" function of maintaining law and order from the process of judging another person's worth as a human being or lack thereof? For one thing, we are often very complex mixtures of good and bad, such as the Mafia boss who is loyal to his family. Right and wrong can also be very relative—thus a gang member kills the member of another gang and goes to prison out of duty to his associates.

People also change—should there not always be a path to redemption? And wasn't there that famous desert dweller who admonished an angry crowd about to dispense some "frontier" justice: "Let he who has not sinned cast the first stone." Any volunteers?

Learning from my own personal experience, as well as what I have heard from patients over many years, there is the potential for great wisdom to be had in having "sinned" and accepting responsibility for it. After having done something wrong, we must learn to live with the fundamental disappointment in ourselves and any guilt or shame that goes with that reality. Both guilt and shame are the products of remorse, but they are not the same. As summed up nicely by Brené Brown, guilt is the pain of acknowledging that you "did something bad"; shame is the conviction that *you are bad.* Of the two, shame is the more malignant, because it makes it far more difficult than guilt to accept that we made a mistake and move on.

It seems to me that the key to living with mistakes is the understanding that, although we cannot change what we have done, we can use our guilt or shame to forge a lifelong conviction to

never make the same mistake again. Over time, staying faithful to such a vow can restore our dignity and self-respect, which is a bit of a "zero-sum game" overall, in that presumably these were largely intact before we began this journey. I see opportunity in making mistakes, however, in that we can emerge ever so much better than we were before the mistake(s) happened. This is by virtue of the potential for the emergence of *humility* (from realizing that we, too, are flawed) and *compassion* (for having experienced the pain of failure)—including for ourselves.

We each carry within us the capacity to dwell within our own personal Garden of Eden, a place of order constructed by making virtuous choices in the face of temptation. Alternatively, we may also condemn ourselves to exile in the Wilderness—the chaotic, meaningless Universe that lies outside the borders of our Garden. The place that we choose to dwell is the great drama, the arc that defines our lives. It is a play in which we act and never know the end until we die, for the temptation to make yet another mistake is never far from us.

One parting shot on the topic of sinning: After years of experimentation with being both virtuous and not, I propose a new marketing strategy for the Ten Commandments. In this age in which no one trusts authority any more, perhaps they would be more widely accepted if they were not presented as an Official Rule Book from On High but rather as a Guide to Happiness. You know, a pithy, ten-sentence checklist (having the original version printed on stone likely made brevity a high priority) on how to live a healthier, more fulfilling life—sort of a "beta," desert-fired version of one of those modern self-help books that are so popular nowadays. How about the Ten Recommendations? Work for you?

But what's going on in yet another category of mistakes, in which the poor souls who commit them make the same errors over and over again, despite the lack of any personal pleasure or gain? This lack of any obvious reward means that we're no longer in the moral domain of sinning, so put away *The Holy Bible* and let's talk Freud. These are ingrained patterns of self-destructive behavior, as exemplified by those who keep entering physically abusive relationships or repetitively make self-defeating career choices, despite the consequences or any perceptible positive reward. Such behavior is often seen in victims of trauma or those who grew up in chaotic, dysfunctional families. These individuals are often eerily unaware of what they are doing. Even when it is pointed out to them, they are often incapable of stopping. It is as if they are puppets upon a string, jerked about by an invisible hand. This type of behavior is often an attempt to fix (or undo) something from their past that defies being fixed (undid?). It is a life of trying to assemble a 5,000-piece jigsaw puzzle when one hasn't been given all of the pieces, or even a picture of what it's supposed to look like when completed. Psychoanalysis has provided a term for this type of behavior: "repetition compulsion." William Faulkner captured the gist of the problem when he famously wrote in *Requiem for a Nun*:

"The past is never dead. It's not even past."

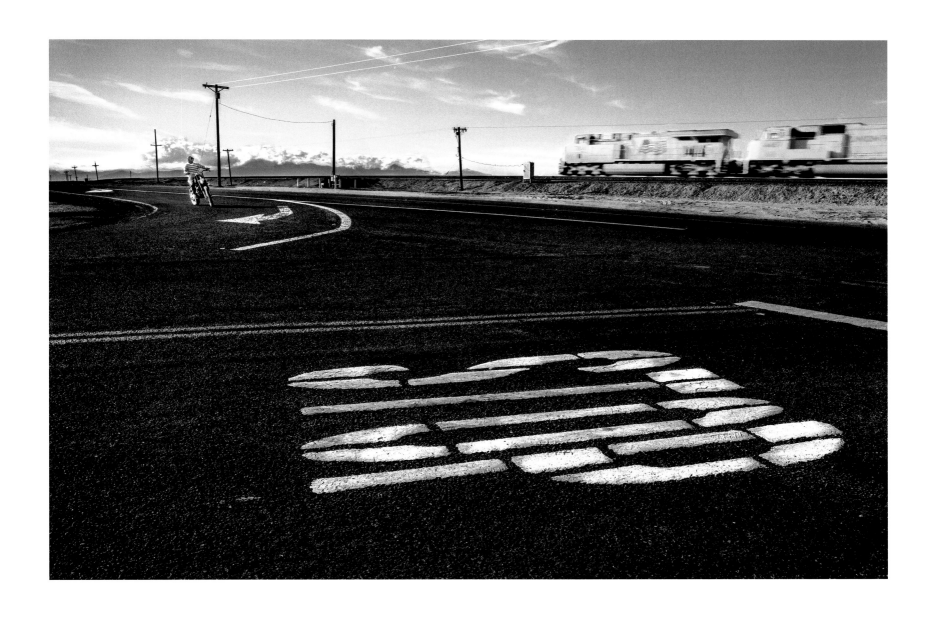

STRANDED IN BARSTOW

"If it wasn't for bad luck, I wouldn't have no luck at all."

—William Bell, from the song *Born under a Bad Sign*

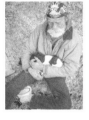
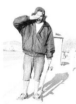

Ready for some fantasy? This story was inspired by images such as *Railyard, Barstow* and *Black Bird* as well as the man and dog in *Beneath the Trestle*. Its primary source, however, was the few bits of personal history that I know about the young man who appears in the portrait, *Stranded in Barstow*. Early one morning, I saw him from my car walking along Main Street, there in Barstow, which is actually old Route 66. I pulled over and asked him if I could take a few pictures, and he consented. The sun was low and quite bright (which is why he is wiping his eyes), but he was gracious and waited patiently for me to finish.

In the course of our conversation, he told me he was "stranded in Barstow." When I asked how long he had been there, he responded "two years." I was a bit taken aback, expecting an answer denominated in days or, at most, weeks. I have actually encountered a very similar story with different particulars from a young fellow "stranded" (he used the same word) off Exit 359 on I–40 in Lupton, Arizona—in his case, for three years. These encounters make me wonder if there is not an entire diaspora of such folk, living near whatever interstate exit the events of life have conspired to place them, washed up in that place, like so many seashells upon the shore.

His response got me thinking about the way in which life often does not turn out the way we planned and the degree to which chance powerfully shapes all that happens to us. The story also gives us a chance to explore the complexities of the universal human experience of *temptation*.

At first, Fausto was only half awake, existing for the moment in that timeless world in which one is neither awake nor asleep and all things are possible. He had, in fact, been dreaming, and strangely the dream had ended with a line he remembered hearing many years ago, from some old black-and-white movie on TV that he had walked in on as a kid: "Whoever you are—I have always depended on the kindness of strangers."

He couldn't remember anything else other than that ending, but it had stuck with him through the years, as it was disturbing. The character who said the line had one of those honey-dripping Southern accents, somehow much-despised by the world at large but, when in the hands of the right operator, able to transform even the most banal thought that a person might utter into gliding verse, sweet to the ear. But what had made the whole thing stick in his memory was the look in the woman's eyes—a haunting calm-in-the-midst-of–the-storm serenity that was clearly inappropriate to whatever else was happening in the character's life at that moment.

Strangers . . . it had been his experience, unlike hers, that strangers did not merit such trust. Encounters with strangers were like being dealt a face-down card in poker. It was just a matter of luck; that is, I mean, not knowin' what kind of card you were actually getting—high or low or maybe even wild. Sometimes, once you got the chance to take a peek at it . . . it wasn't so good.

His reverie was abruptly shattered when the earth around him began to rattle, and there followed a sound so loud that it seemed this might be the Judgment Day. His eyes flew open, and what he saw was a bit of a puzzle, trying to remember just where he was and how he had gotten there. The first clue was the massive grid of oil-stained wood and steel just inches above his nose. Through it, he could make out one of those morning skies typical of a calm day in the Mojave Desert. From its great height, the sky seemed as if detached from the earth, indifferent to the cares of this world, serene in its unblemished, cerulean perfection. That sky abruptly vanished, rudely erased by a smeared phantom of frantic motion, wherein dwelled the thunder of massive diesels and screeching steel. An enormous freight train was rolling at great speed, seemingly on top of him.

His body instinctively recoiled in fear, and, as it did so, he tumbled down the dusty slope into a dry arroyo beneath the trestle, coming to rest at the base of a small, lone tamarisk tree. "Hell of a way to start the day," he muttered to himself, feeling a bit foolish. He stood up, dusted himself off, and took a quick glance at the sun-baked landscape in which he found himself. It was a wild, lonely place, shimmering even at this hour in that volatile mix that is light and heat—a virtually featureless plane but for the railroad tracks stretching from horizon to horizon. Off to the east, a distant mountain range hunkered down low in the haze. "Yes sir, *hell* of a way to start the day," he repeated, this time with more passion-—feeling both foolish and thanking his lucky stars that he was alone, with no one there to bear witness to that embarrassing dismount from his hiding place. Except that he was not alone.

He would now be dealt a card, the first of this hand.

"What's that you say, son?" The person asking the question was an older, very sunburnt man—obviously a hobo. He had a gentle manner and moved slowly. The only thing scary about him was the filthy black bandanna across his head. It was emblazoned with a skull on fire, with great flames licking about its hollowed eyes. The net effect on the beholder was such that, whenever he looked one's way, it was as if they were being regarded by four eyes, not two.

"Howdy, name's Faer. Why, that's just the mainline of the Burlington Northern Santa Fe you been sleeping under. That there freight, she's 'a gatherin' speed, comin' outta' the Barstow railyard, so's she can get acrosst' the next hundred miles or so of dagnabbed desert just as quick as humanly possible. That engineer 'ull be sleepin' in Flagstaff tonight, up there yonder high in the mountains where it's cool and green in the Ponderosa pines, banging his ole' lady . . . at least that's what I'd been doing if I was him." With that, he gave a relaxed chuckle, which, if nothing else, put Fausto at ease. "What's your name, son, where you headed?"

Fausto told him his first name but not his last. No sense in anyone knowin' anything more about him than they absolutely had to. "I come outta' Vegas, tryin' to work my way over to LA. I'm tired of lookin' at this damn desert. I wanna' live some place nice and green for a change." He was hoping he sounded tough and worldly, and so he did not tell the man that he was only seventeen or that he had just run away from home a week ago.

"I shore 'kin understand that, wantin' to see some green. Trouble is, everybody else is thinkin' the same thing. Seems like evurbody an' his kid brother wants to live in them places nowadays. Too damned crowded for me. Say, son, you look hungry, you want somethin' ta' eat?"

With this offer, Faer turned to his poke beneath the trestle to get some food and water for the both of them. It was then that Fausto noticed the little black and white puppy, curled up asleep on top of the man's pack. The old hobo picked up the little pup and stroked his ears a few times before gently placing a few bits of dog kibble before his nose. Fausto noticed how red the skin of the man's hands were, most likely scorched to the color of lobster claws by countless days of exposure beneath the desert sun. Faer's obvious love for the helpless little animal set Fausto even more at ease, because he instinctively understood that a truly bad man capable of doing harm to him would never show such love.

Fausto relaxed, and, as they ate a tin of sardines and bits of stale crackers, he told his story.

"I left my daddy 'bout a week ago. I was born and raised in Vegas. The first few days on the road, I didn't really think much about where I was goin', so I just headed out . . . why, first place I wound up was Kingman. Couldn't find me no work there, and that's when I decided I'd head for Los Angeles. I've heard that's Mexican for City of Angels, so I figure can't be all bad."

That's right, Fausto was fleeing to the City of Angels from his home in the City of the Devil—Las Vegas. Las Vegas means "the meadows" in Spanish, but there are no meadows there now—never were. It was just a stretch of real cheap dirt far from where anybody else could watch what was going on. Here, the "founding fathers" built a glittering empire (actually quite beautiful at night when regarded from miles away) based upon the shrewd calculation that people would be drawn from far and wide by the siren's call of *Lady Luck*. Yeah, what happens in Vegas stays in Vegas—like whatever money any sucker might have brought to town. At the age of seventeen, he figured there had to be something better out there somewhere in the world. At least he had to take that chance.

For, you see, it was hard to know if the word "home" was really appropriate for the place into which Fausto had been born. It is the matter of what home one is born into that is always the first and most important card that one gets dealt in life, despite the conceit of so many who convince themselves otherwise. For it is that first card whose power permeates every hand that is to follow. This is one of the ways that poker is unlike life, for in poker all cards are weighted equally, and players begin again from scratch with each hand, as if nothing at all had gone before. That is not to say that in either activity the skill of the player in handling the cards dealt to them does not influence the outcome. But poker, unlike life, is a game with rules that make it fair.

Fausto didn't think his father was necessarily a bad man, just broken. His dad had been lucky enough to get the chance to marry his high school sweetheart, Eve, and they had exchanged solemn words of the "until-death-do us-part" ilk. Unfortunately, as it happened, the words turned out to be just that—words. At first, things went well enough, and the happy couple had three young boys in rapid succession, all of them in various stages of diapering. But, by coincidence, Eve had chosen to shop at a local grocery store where a serpent lay in waiting along the checkout lines. There it offered her a bite of the Apple of, regrettably, Incomplete Knowledge. For those checkout lines teemed with row upon row of glossy celebrity magazines. The women in them lead exciting, glamorous lives, and were more like goddesses than mere mortals. I say incomplete, for what the magazines did not show was the ennui that was also part of that world. No, that doesn't sell magazines. But Eve was naive about such realities and vulnerable to seduction. She grew mean as she faced a life of countless days changing diapers and picking up after three hyperactive, messy boys. She was unaware of the transformation that was occurring within her until, hey, there it was, and so one day she just up and left, without warning.

Of course, Fausto's father was stuck with the reality that the woman he thought he married was, in fact, a stranger all along. And so, his dreams shattered, he drank—way too much, because

that was the only state in which he could be numb. But although alcohol has been prized as an anesthetic from the day of its discovery, it also has an unwanted side effect—it diminishes impulse control. And it was in this domain that the demon of rage that lay dormant within him came unchained. When drunk, he would beat the boys, typically cornering them in some room, pulling off his belt and striking them repeatedly with the buckle (although never in the face and arms, because that left bruises that were readily visible). There was always some excuse, but the real reason was quite simple: Eve had left him because of them.

Faer listened to Fausto's story patiently, understanding that the telling of such a story was much like the flow of puss from a suppurating wound within the bearer. He felt a deep connection to him, for theirs was the brotherhood of suffering. At its conclusion, he said he was sorry that all of this had happened, and then he offered: "You know, son, despite all them whuppins your daddy laid on you, don't seem to me like you got much meanness in you . . . yet . . . But the world can be a tough place, 'specially for them's not prepared. Now I wanna' give you sumpin' might help you in a scrap, so's you can be safe. Keep it hidden—don't never show it to nobody, less'n you gotta use it."

With that, he shoved a switchblade into Fausto's hand. Fausto had never seen one before and was fascinated by the cool insouciance that seemed to ooze from the instrument. He flicked the innocuous-looking lever on the handle, whereupon—quick as a flash—a truly wicked two-edged knife blade sprang, as if by magic, from the handle. Fausto thanked him for the gift and stuffed it into the butt pocket of his jeans. He then picked up his few belongings and made his way over to an exit ramp on I-40.

Time now for another card, his second.

He stuck out his thumb, and pretty soon he had a ride who told him he could take him somewhere close to Daggett. It wasn't but a few miles down the road, but he figured he might be able to find some work there and raise a few bucks, because he was broke.

The driver got off at the appropriate exit and stopped. Fausto gave him a quick handshake and thanked the man before jumping out of the car. He did not know it, but, as fate would have it, he was standing on the remains of none other than the legendary Highway 66, the Dust Bowl era Trail of Tears. The road was basically empty in both directions, save for one old ramshackle dump about a half-mile down the road. Figuring this was his only option, Fausto started walking, kicking rocks as he went.

He arrived at a rather dilapidated cluster of buildings beside the highway that looked as if, in its heyday, might have been quite a going concern--a combination of gas station, café, and motel rolled into one that definitely had seen better days. There was a creaky old sign, swinging erratically back and forth in the fitful wind. The letters had faded long ago, and so the name of the place was illegible, although three crimson letters had withstood the test of time as if they had just been painted yesterday: EAT. On one wall near the front door, he could discern the faint message "FUCK U," despite what was apparently a rather half-hearted attempt to wash the greeting away at some time in the past. There were no cars about the place, other than one old rusty sedan parked out back. Sizing up the joint, Fausto concluded it was altogether pretty sorry-looking, but it was either try his luck here or do a whole hell of a lot more walking—which, in the 110 degree-plus midday heat, was not a pleasant prospect. He was hot and tired; he decided he had best go on in and take his chances.

And here came his third card, sailing at him across the table of life.

"Hey, shit-for-brains, why don't you come on in and close the damn door? You're lettin' flies in! Course' there ain't a fly within a hundred miles of this hell hole unless its lost or stupid. Which one are you?"

And that was how Fausto's encounter with Mr. Maleurous began. As he blinked in the sudden darkness in which he found himself after closing the door, Fausto studied the man facing him. They were alone, other than a large black raven with iridescent wings who sat in a cage, apparently disinterested. Curiously, the door of the cage was left open. Mr. Maleurous stood next to an old counter that divided the room. That counter was topped with a battered sheet of Formica, the face upon which was written the woes of many a weary traveler in a code of ancient chips and stains.

Mr. Maleurous was a short fireplug of a man, less than five feet tall, and sported an outlandishly large pair of filthy, badass cowboy boots along with a very bad toupee thrown carelessly across his head. One's immediate impression was that of a nasty clown. He seemed to be about 60 years of age and looked like he hadn't shaved for several days. His sweat-stained shirt was half-unbuttoned down his chest, due to the suffocating heat in the room, and from their perch a forest of graying chest hairs peeked out at the world. But there were two things that were his most distinctive features. The first was a large, black cigar, never lit, that thrust out from the bristles of his dense, untrimmed mustache. Fausto would learn that this cold stub lay perpetually clamped between Mr. Maleurous's teeth, shifted for dramatic effect from one side of his mouth to the other whenever he wished to emphasize a point. The stale aroma of cigar smoke gone bad seemed to pervade the tiny room.

And then there were his creepy, startling eyes, those windows of the soul, which were magnified by a set of black horn-rimmed glasses equipped with a pair of Coke bottle-thick lenses. From the perspective of the beholder, the lenses functioned much like twin *microscopes*, making Mr. Maleurous's eyes appear much larger than they were in reality. As a result, one could see every small detail of them, beginning with the vessel-marled whites. The irises were especially agitating to behold—blending as they did from dark olive at their margins to a tiger-yellow annulus at their center. It was an effect not unlike two bullseyes, except that energy seemed to be coming from them, not at them. And as light travels in two directions, it was easy to imagine that, for Mr. Maleurous, the lenses in his glasses functioned as twin *telescopes*, yielding both supernatural powers of observation and the ability to focus all that energy emanating from his being with X-ray intensity.

For just the briefest moment, Fausto had the unsettling perception that Mr. Maleurous's pupils were more slits than ovals, like those possessed by the Devil himself. Fausto blinked and the illusion vanished, as if it had been a mirage. The overall effect was quite fantastic and unsettling, but Fausto decided he had gotten this far into the interaction, and he might as well take his chances with this crazy-looking old geezer.

Fausto chose to ignore that last question and instead rely upon a repsonse that attempted to blend a dash of obsequiousness with a bit of youthful charm. "Well, sir, I'm trying to make my way over to LA. I'm pretty much outta' money, and I was wondering if there was anything that you needed doing around here, so's I could make me a little spare change."

Mr. Maleurous seemed to pause, sizing up the person who stood in front of him before saying anything. "Run away from home, did you? You little bum . . . I bet you never did an honest day's work in your life! Probably stole everything your parents had before you left home, just to show 'em your heart-felt gratitude. Probably a drug addict, too. Little bastards like you are a dime a dozen . . . come in here all the time, looking for work."

Fausto was taken aback by this additional barrage of abuse, especially since his identity as a runaway had been accurately nailed. It was disconcerting—having been found out so quickly—and that left him feeling vulnerable and as if he had something to prove. So rather than turning on his heels and exiting as quickly possible, he made a fateful decision to stay and somehow redeem himself to this stranger. Mr. Maleurous was cunning enough to spot this dynamic as a weakness that might be exploited.

"Look, I'm just trying to get to LA, so's I can be with my family. I got a sister who's sick, and I haven't seen her in almost a year." Fausto was especially proud of that last flourish, which he had embellished on the spot, in hopes of evoking some sympathy. But, being so young, Fausto was a terrible liar, and, besides, the heart to which he was speaking had turned to stone ages ago.

"You really are a hot mess, aren't you, Mr. Tiny Dick? I bet you ain't even got a sister . . . in LA or, for that matter, anywhere else."

Fausto was again unsettled by the degree to which this man could see right through him, as if he knew every secret that he possessed. The more vulnerable Fausto felt, the more he desired to please the person who was ridiculing him.

And so he persisted. "Okay, I made up the part about my sister, but I really am trying to get to LA. I just wanna' make a few bucks, so's I can be on my way." It was then that Fausto's eyes fell upon the conspicuous bulge in Mr. Maleurous's left shirt pocket. It was a big, fat money roll, and Fausto was quite certain he could make out that magic number "100" through the sweat-soaked cloth.

Having discerned the object of Fausto's attention, Mr Maleurous took the money out of his shirt pocket and quickly jammed it into his fat, funky sweat-soaked wallet. "Hey, you little prick. I can see your eyes lightin' up, and I know what you're thinkin'. . . So listen up, sonny boy, real damned good. You best forget about that wad of cash you just seen, 'cuz I got me a .38 Special 'round here, and she's loaded up with hollow points. That'll blow a hole in your fuckin' chest big enough for me to reach in and rip out whatever's left of your beating heart. You *sabe?*"

And Fausto felt ashamed, for here, once again, this little man with the strange eyes had seen right through him, as if he could read his mind! For, make no mistake, Fausto was tempted, gun or no gun. He licked his lips nervously as he thought about how much he sure could use that money, and, besides, maybe the story about the gun was a lie. But the money was not his, and, for him, after some quick thinking, that settled the matter. Little did he suspect until many years later that it had been Mr. Maleurous's intention to place temptation in his path, deliberately setting a trap for him as would a spider for a fly. Virtue is merely a possibility until tested by choice.

"You got me all wrong . . . all's I'm looking for is work. I've never stolen nothin' from nobody." And that was true, which Mr. Maleurous seemed to discern, although unknown to Fausto, he was inwardly disappointed but had not given up—yet.

"Well, alright, I'll give you a job, but my advice is: Don't you go getting' all hot and bothered, daydreamin' about what you could do with all that cash. I know a young fella' like you sure could use that money, but you got to make it the way I did—the *hard* way." With that said, Mr. Maleurous figured he'd done enough to challenge Fausto's finer instincts for the moment—he'd just let Fausto marinate in the possibilities of what he could do with so much money (getting it the *easy* way) for awhile. For, you see, when laboring in the Garden of Temptation, Mr. Maleurous was a patient fellow, as he had learned through the ages that with the application of the proper fertilizing ingredients, particularly repeated exposure and time, even a tiny seed might one day bear delicious fruit. Now, he abruptly turned and lead Fausto out back into his yard. "Alright, so I

want you to pick up all this trash and old wood, stack it right here, then burn it." As he was giving instructions, Mr. Maleurous cut a neat "X" in the sand with one of his freaky old boots on the spot where he wanted the fire. It was near a small wooden shed, but the wind was blowing in such a way that Fausto did not think there would be a problem. He got to work and had soon created a large heap of trash. He started the fire, which rapidly grew to be quite large.

Time now for the fourth card.

The wind had been blowing all day long from the north, but an afternoon thunderstorm had moved up from the Gulf of California, with its own ideas about which way the wind should blow. And so it was that the wind switched directions, now coming from the south and blowing hard, kicked up by the great storm that was approaching. Delicate veils of rain trailed behind the enormous cloud—a churning squall rendered in dark shades of charcoal and blue. But not one drop would touch the parched earth, for all of the life-sustaining water that fell from the sky would evaporate in the hot, dry air long before it hit the ground. All of the creatures beneath the clouds would be left, wanting—waiting for their next shot at the gift of rain on some other day. Hey, that's life in the desert.

Fausto realized with a start that flames were now licking at the small building, which began to smoke, then burn. He ran to get Mr. Maleurous, who took one look, and went berserk—*postal*.

"You good-for-nothing dumbass, why'd you put the fire there, and what were you thinking, making the pile so damned big? What are you, a moron or something?! Why, I should have known better than to trust you to get this job done without screwing it up!"

Fausto responded that Mr. Maleurous himself had chosen the spot, but it was no use; Mr. Maleurous wanted someone to blame. He abruptly seized a two-by-four from the ground and began beating Fausto viciously with it, his face shot purple with rage.

At first, Fausto was able to protect himself by raising his arms to his head, but the blows just kept coming. He began backing up, trying to get away, but Mr. Maleurous pursued him. Eventually, Fausto stumbled and fell, putting his hands behind him to cushion the fall. That is when he landed on his backside and felt the shape of the switchblade in his rear pocket. What happened next was really more a matter of reflex than anything, shaped by both the instinct for survival and his own pent-up fury and self-loathing after so many years of being beaten by his father. His body and the knife became as one, both instantly triggered to one purpose—and that was how Fausto found himself watching, almost as a spectator, as the razor-sharp edge of the knife was traveling across the vulnerable flesh of Mr. Maleurous's throat, cutting with such force that the blade went clear down to his spine, the incision stretching from ear to ear.

Mr. Maleurous fell backwards onto the ground, dead with little more protest than a faint gurgle. The wound lay gaping below his jawbone, like a lipstick-smeared, macabre grin, smiling triumphantly back at Fausto. As he still wore his glasses, the eyes of the dead man remained immense, staring straight *through* him, no doubt looking at the gates of hell. Lying in the dirt, the corpse was both ghastly and comedic, not unlike some bespectacled, gruesome scarecrow.

Fausto's first impulse was to run from the scene, as if by doing so he might escape what had just happened. But there is no one who can run so fast as to elude memory, and, besides, something amazing was happening there in the sand at his feet. A great pool of blood was forming, its source from two springs. One was that of the carotid arteries—this blood still pulsatile with what would be the last faint contractions of Mr. Maleurous's still-beating heart. Its color was bright red, for it was even now still laden with oxygen, unlike that from the second spring, which was the steady oozing drainage from the veins of the neck shaded deepest purple-blue.

Fausto sensed that it was in the gap that was the space between these two states of blood, light and dark, where something wondrous had occurred, and therein lay an understanding of the sweet, vulnerable Mystery that is life. He watched as both tints of blood, the red and the blue, inevitably coagulated and faded into black, and, thus transformed, the pool faded yet again into the silent, adoring, passive, infinite sand, as if it never was—back into the earth from which it came.

 It was the vision of the scarecrow that would haunt Fausto for the rest of his years. But that was trouble for another day—on this one, at this moment, Fausto was suddenly, deeply, profoundly at peace. The desert air had become motionless, now rendered thick and viscous with the intangible, as if angels were hovering about him. It was good to be alive.

That feeling left as abruptly as it came, for there was much to be done and quickly. Fausto looked in all directions to see if there had been any witnesses. The only thing watching him was the large black bird, which must have somehow left its cage and escaped. The bird examined him from the safety of its new perch, clinging to the branch of a small tree as it heaved about in the strong winds driven by the storm. It cocked its head from one side to the other, as if judging whether or not the fight had been a fair one. If the creature had an opinion, he kept it to himself, for it made not a sound. It just kept watching.

Fausto quickly buried the body in the ocean of sand behind the buildings. He did not touch the money roll in the shirt pocket, as he would remain an honest man. It would be days before anyone realized that Mr. Maleurous had disappeared; no one much liked him anyway. Why, there were even those who whispered that he had likely finally done something mean enough to piss somebody off, big time—and gotten what he deserved. He would not be missed, and nobody particularly cared who did it.

Fausto quickly gathered up his things to clear out as quickly as possible. By now, the storm had moved off to the northwest up towards Baker, still heaving in futility and consumed within itself, doomed never to leave even a trace of moisture upon the earth as evidence of its existence. Fausto took a moment to clean up and compose himself before he walked out of the cafe into the eerie calm left behind by the storm. He decided that, rather than getting back on I-40 to hitch a ride, he would try his luck on Route 66, as it seemed he'd be less likely to run into a nosy cop.

Whereupon he got the fifth and last card of this hand, casually flipped his way.

This time it would come as the absence of an event, rather than its occurrence. For there is almost no traffic on this largely abandoned highway, and the few who did pass him by saw a drifter who may or may not do them harm. They weren't willing to play this hand. What does not happen in our lives is as important as what does, and so, in this case, Fausto would hoof it the ten miles to Barstow, and there, stranded, he would stay.

All of that had occurred many years before. Fausto stayed on and was able to get a job and even fall in love. His father-in-law was a kind man, who treated him with respect. He had his first child and would remain there in Barstow, where he became a pillar of the community. Upon his death, the local high school would be renamed in his honor. He would play many more games of chance in the years to come, for this is our destiny. His secret lay safe within him, and it was almost as if the whole thing had been a bad dream. Except that he would be haunted by the memory of the ghastly, grinning scarecrow that was his last view of Mr. Maleurous, as well as by a large black raven that would seem to follow him for the rest of his days, watching . . . watching from the safety of his perch in the trees.

As he was both young and naive, it would be many years before it ever dawned on Fausto that he had, in fact, in the form of Mr. Maleurous, encountered a minion of the Devil himself. That had

been the purpose of the big wad of hundred-dollar bills in Mr. Maleurous's shirt pocket—to nudge Fausto in the direction of a life of evil, for the prize to be had in the kitty of this hand of poker had been none other than Fausto's soul. It had all been a test, and this time Fausto had passed. But Mr. Maleurous was a skilled poker player, and, in Fausto, Mr. Maleurous had sensed opportunity. Although the cards had not fallen his way in this hand, Mr. Maleurous had assumed the form of the raven, a *nahual*, in the hope there might yet be another round to be played with him.

That never happened. And do not be troubled by the manner of Mr. Maleurous's death. It was all a game to him, and, being a spirit, Mr. Maleurous was indifferent either to the manner of his death or to whatever guilt might trouble Fausto in the years to come. He had become bored with the game and frustrated, since he had been unable to steal that which he coveted—Fausto's soul. And so he simply drifted onward, as he had so many times before, to the next abandoned exit on the endless highway, searching for yet another round to play in the timeless struggle between good and evil. People are weak and flawed, perhaps by design, and thus the outcome of any hand is always in doubt—but even the Devil is only as good as his last cards. And that, my friend, is why the Devil wanted to play. As even for the Devil, games of chance will always be a temptation too sweet to resist.

> I don't care where you bury my body when I'm dead and gone
> You may bury my body down by the highway side
> So my old evil spirit can get a Greyhound bus and ride.

> —Robert Johnson, *Me and the Devil Blues*

Now if you have read the other stories, you will immediately recognize that the ruling deity at the conclusion of this story is the God of Love, for Fausto escapes his ordeal to live happily ever after. For those of you who hue to a God of Wrath, I attempted to write an alternative ending with an appropriately grim outcome, but I was incapable of convincingly doing so.

Perhaps this will prove to be a fatal flaw in my concept, for it seems that dark endings have always been regarded as superior. As an example, on the Mental Floss Website, one of the co-writers of the screen play for the movie *Easy Rider*, Terry Southern, is quoted in an interview that he gave for *Creative Screenwriting* as saying that the original version of the screenplay for the movie was to end happily, with the protagonists metaphorically riding off into the sunset, to die old and fat in some place like Key West. But apparently it was decided that the two of them had to be killed at the end to provide a "genuinely artistic dimension" to the film. Why do we so love tragedy? Is there not enough of it in the world? Perhaps that is why it fascinates us so when we face the inevitability of its occurrence in our lives. But I could not kill Fausto. I was Fausto, once—at least in spirit—and I could not kill myself.

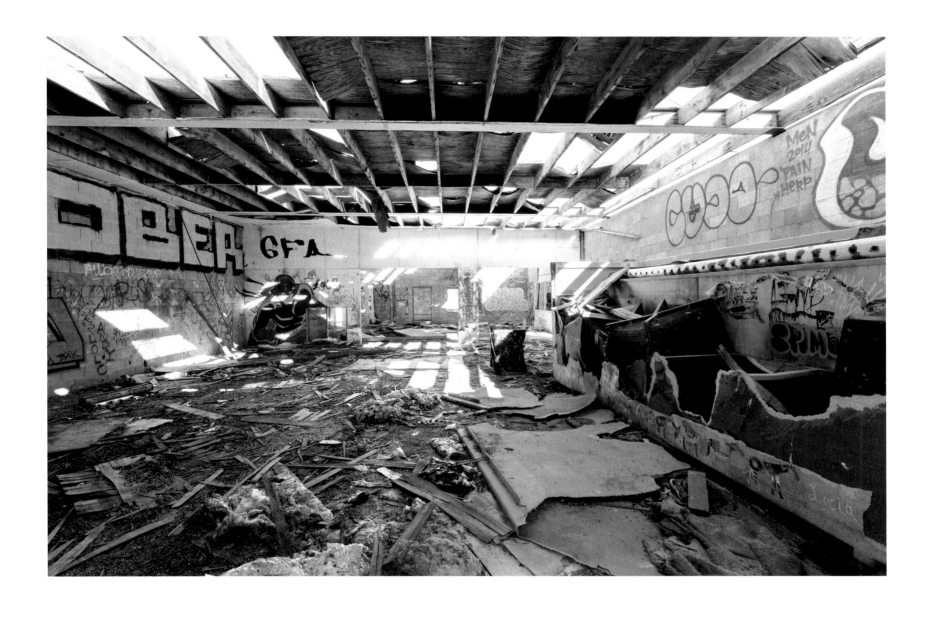

VISIONS OF GOD

"Religions do a useful thing: They narrow God to the limits of man."
—Victor Hugo

He approached me and shoved a card in my hand. We were on an anonymous patch of desolate beach at the end of a crumbling, unmarked road leading to the Salton Sea. His ancient white pickup had a camper slipped into the back, and, from the look of things, he had dropped anchor here some time ago. He told me he lived in Northern California and came down here in the winters to get some sun. He confessed that it took some time to get used to the appalling smell of dead fish that hung over the place but that, eventually, one got used to it. We laughed.

I looked down at the card he had given me. It was the size of a business card but bristling with citations of scripture. The density of it made it unintelligible, and yet it also communicated a sense of urgency by its very impenetrability, like the feeling evoked by a stifled scream: God was angry with us, and Judgment Day was coming. He spoke excitedly about the coming of Jacob's Calamity, and thus emerged the title of the photograph, *Waiting for Jacob's Calamity*. His was a God of Wrath, on the prowl, menacing—looking for trouble. I then realized that his vehicle was not so much a recreational camper but more like a tiny ark—self-sufficient and prepared for the end.

About 50 yards from that camper is the hand-painted sign seen in another image, *Last Chance to Evacuate*, which says: "Last Chance to Evacuate Earth." I'm pretty sure that he painted it, but we never discussed the issue.

How different this perception of God is from that of Leonard Knight, the man who spent decades laboring in obscurity less than 15 miles from where we now stood. He created Salvation Mountain, a monumental earthwork covered with ecstatic messages and verses from *The Holy Bible* that appears in the image, *Stay Off Heart*. It is painted in orgasmic colors, as Leonard Knight's exuberant message is that of a God who is full of nothing but Love. This God is looking for somebody to hug.

How can one reconcile two such profoundly different views of whatever "God" is? I am reminded of Paul Gauguin's painting, *Vision after the Sermon (Jacob Wrestling with the Angel)*, completed in 1888 after his break with Impressionism. Based on Genesis 32: 22–31, it depicts a group of nuns watching a wrestling match between these archetypal figures. That painting, and the disparate beliefs held by two strangers (one living, one deceased) that I encountered at the Salton Sea, served as the inspiration for this story. I thought that we might get the whole question resolved of which Vision would prevail if we had them embodied as angels, fighting it out in the setting of a modern Mexican professional wrestling match. *Bring it on*, my brother!

One final thought: Whatever the outcome of the imaginary wrestling match to follow, I believe the diversity of opinions about what God is *really* like tells us more about how each of us would run things if *we* were God, invested with all of that power and responsible for the Universe. Which God lies dormant within you?

Announcer #1: Ladies and gentlemen . . . welcome to tonight's Wrestling Extravaganza—why, it's a veritable Rasslin' Lollapalooza, yessiree! This is the evening that has been thousands, if not millions, of years in the making, but tonight at last the Dream Match is here.

Announcer #2: Yes, that's right. Finally, the faceoff between two epic champions: Sombras, the Dark Angel of Wrath, and Luz, The Bright Angel of Love. And for those of you watching from home, you can't imagine a more electric atmosphere. I mean the crowd is stoked! Each side is chanting in unison for their heroes, back and forth, back and forth—pulling with everything they've got for their respective Vision of the Universe!

Announcer #1: Now, as you may know, rumors have been circulating that tonight's match is being held because God is displeased. Fewer and fewer people have been going to church in recent years, and so tonight God is reaching out, trying to make religion fun for people once again and get those ratings up! You know, like in the olden days, before science and mass media and all of those secular things that have lead people astray! How often do you get to see a spectacle such as this?

Announcer #2: Exactly right. It's really back to the good ole days of Bread and Circuses, don't you think? And, as if anyone needed any more reason to watch the fight tonight, both fighters are completely healthy and ready to kick some you-know-what, having recovered from recent injuries. I mean, Luz took the existence of Hitler and Stalin really hard. And then, as for Sombras, there have been a lot of rumors circulating that the whole Gandhi-Martin Luther King, Jr. thing just did not go down well with him at all, what with that nonviolence message. And to top it all off, there was the 2008 presidential campaign in America, with all of that talk about Hope—it was just icing on the cake. Now, that didn't seem to go much of anywhere, but, from what I've heard, it shook up the Champ pretty bad! I mean, he didn't know what was coming next, like maybe World Peace or Brotherly Love. But with recent trends in American politics, I'm told that Sombras feels a lot more confident that things are pretty much getting back to normal.

So, bottom line, the forces of Love and Wrath have been pretty nicely balanced these days, and, tonight, both fighters are healthy and in top competitive form, eager to give it everything they've got.

Announcer #1: Let me tell you, I'm all fired up, as the stakes couldn't be any higher! It's winner takes all, 'cause whoever loses tonight, they're number two—for all of eternity!

Announcer #2: Uh, oh! I'm sorry to interrupt, but I think something is happening up above the ring. Wait a second . . . yes, I'm right. Luz is making his entrance from the ceiling, suspended on a cable hanging from a giant crane. Wow, is that clever or what? Just listen to this crowd roar its approval! Everyone here has jumped to their feet, I mean just flabbergasted by the awesome showmanship on display here tonight!

Announcer #1: And, as our home audience knows, he's dressed all in white, including the mask that is pulled completely over his face and head, so as to hide his identity. And now he's spreading his great white wings and pumping them open and shut. It is a spectacular sight to behold!

Announcer #2: I mean, is this guy a showman or what?

Announcer #1: Okay, the crane has lowered him to the point that his feet are just touching the mat of the arena . . . and there's his manager to remove the harness that was keeping him suspended. Luz is looking fired up and very pleased with himself; he's stalking around the ring and pumping his fists into the air.

Announcer #2: And now it's Sombras's turn to enter . . . I can't wait to see just what kind of stunt he's going to pull.

Announcer #1: Wow, I don't believe what I'm seeing . . . what is happening right now on the floor of the arena in front of me! A trap door has opened up, and now Sombras is being raised on some type of elevator, up to the level of the crowd from only God knows where. And the people assembled here in the audience tonight are just going wild! Just listen to that thunderous roar of applause! And how about this touch? As he makes his way to the arena, he's striding between two rows of fireworks. Rockets are shooting into the air, and there are huge showers of sparks surrounding him. The spectacle is *amazing*! And there he goes, spreading those great, black wings, beating them up and down, just like we all know that angels do when they get all riled up! Whoa . . . I sure wouldn't want to run across this dude in a dark alley!

What a scene we are witnessing here tonight, as these two great competitors clash. Both *luchadores* are now in the ring, circling warily 'round each other. Wait a minute . . . I think the umpire is saying something.

Referee: Okay you two, I expect a clean fight tonight . . . no dirty stuff! Now I want both fighters to come out here and shake hands.

Announcer #2: These two angels really do *not* like each other. I mean, just look at that handshake. Why, there's fire shooting out of their eyes, smoke coming from their nostrils. Each one is trying to put a hurt on the other, laying a death-grip on their opponent. These two clearly can't stand to be in the same room together!

Announcer #1: Well, I guess the formalities are finally over. Each angel is going to his corner, waiting for the bell to ring. They're really glaring at each other across the mat. And each of the two fighters is getting a last-minute pep talk from their respective managers, as other assistants are now removing their wings. Now we can see the large heart that is emblazoned on the back of the shirt of the manager for Team Love and, in the other corner, the lightning bolt that is the logo for Team Wrath.

And oh, wait a minute, let me get my binoculars. There's a nifty touch. On Team Love's logo, I can just make out the words "New Testament" circling the heart and on the Team Wrath's logo . . . yes, yes, that's right, just as I suspected, there are the words "Old Testament" around the lightning bolt! Doesn't seem that they got the word from conspiracy theorists that those are misconceptions spread around by the scholars who wrote the first versions of the Bible. Some whack jobs think they interpreted the ancient Hebrew texts to create this false dichotomy between the two views of God as contained in the Old and New Testaments—you know, one mean and the other loving. But what do I know . . . that stuff's, like, *way* over my head.

Announcer #2: And for those of you in our audience there at home who have never seen anything like this before . . . but, oh wait, I guess nothing even remotely similar to this has happened since Adam and Eve got banned from the Garden, so how could you? Well, anyway, the way this works is that there are three rounds, each of them kicked off by a question from a randomly selected

member of the audience. Now, neither of these champions has any clue ahead of time what they're going to be asked, so how about that for suspense? And, to top it all off, they're going to be answering the questions as they actually try to beat the hell out of each other . . . what a concept! You know, kind of like Godzilla versus King Kong, paired with Einstein versus Hawking.

Announcer #1: And the winner of each round will be judged by our panel of three Judgment Day experts, specifically chosen for tonight's event. Now, we've been assured that all of them are A-list celebrities, but no one knows their true identity or what they will decide, because, as we all know, the Universe is Mysterious. We don't get any Answers! How's that for imitating real life? If you don't like the rules, folks, sorry, don't blame me. 'Cause we all know, that's Just the Way Things Are.

And there it is, the bell! The Match of all Eternity is finally under way . . . ladies and gentlemen, it's *showtime!*

Announcer #2: So, let's take you down to the ringside where all the action is happening, so you don't miss a thing. It looks like someone is getting up from the audience to ask the first question. Why, suddenly it's so quiet in here, you could hear a pin drop.

Audience Member #1: Ahemmmm . . . ahemmmm (the speaker nervously clears his throat) . . . So I've wondered about this question for a long time: Why is there evil in this world, and what are you going to do about it?

Announcer #2: Okay, okay, that's a good one. Looks like Sombra is ready to make the first move, and, oh boy, here it comes . . .

Sombra: Evil exists in this world, because Man ate of the forbidden fruit of the Knowledge of Good and Evil, which he had been told not to do. "But of the tree of the knowledge of good and evil, thou shalt not eat of it: for in the day that thou eatest thereof thou shall surely die." The Book of Genesis: Look it up!

Announcer #1: And oh, folks, with that opening shot, Sombra is grabbing Luz's head and shoving it into his knees in a classic facebreaker smash! Looks like there might be some blood running out of his nose . . . Luz seems dazed, but now he appears to be shaking it off and is looking like he's going to say something.

Luz: Yes, there is evil in the world! But then there is also mercy and forgiveness! "For God so loved the world that he gave his only begotten Son, that whosoever believeth in him should not perish, but have everlasting life." The Gospel of John!

Announcer #1: I can't believe my eyes right now, because, even as these words are coming out of his mouth, Luz has picked up Sombra above his head, twirled him, then slammed him on his back, and I do mean *hard*, on the mat in one of his signature moves, the Death Valley driver. Sombra is groaning, but he sits up, and now he is pointing at Luz. Let's listen to what he's got to say!

Sombra: Oh, you think just because Jesus came into this world, the old ways can be forgotten! Well, not so fast, mister! Jesus himself said, "Do not think that I have come to abolish the law or the prophets."

Announcer #2: Man-oh-man, it looks like that zinger really hit home! Just as Luz was charging at Sombra, Sombra deftly stepped aside, then used the momentum from Luz's charge to shove him head first right into the steel corner post. Is that legal? I don't care if you are an angel, that's just gotta' hurt real bad. I wouldn't be surprised if he isn't seeing stars about now.

Announcer #1: And there's the bell to end Round 1. You know, Luz came in here a heavy favorite with the crowd, but I'd have to give the first round to Sombra.

Announcer #2: Yeah, I think I'd have to agree. I mean, Sombra really showed his wrestling IQ after all these years in the business, with that lightning comeback. We're watching a true professional. Very impressive. But wait, things have gotten really quiet again. There's the opening bell, and we're off into Round 2. What a treat!

Audience Member #2: Why is there so much suffering in the world?

Announcer #1: Ladies and gentlemen who are listening there at home, I can't believe my eyes! Sombras has actually begun smiling. He clearly likes this question!

Sombras: There is so much suffering in the world, because humans disobeyed God. They are a craven, degenerate bunch and are being punished for their sins. "Cursed is the ground because of you; In toil, you will eat of it all the days of your life . . . For you are dust, and to dust you will return."

Announcer #2: And, with that response, Sombras is now picking up Luz on his shoulders and doing an airplane spin. But instead of dropping him, he's tossed Luz out into the crowd, so high I'd swear Luz was in low-Earth orbit there for a few moments before he landed. That ought'a put a serious hurt on the Angel of Love!

Announcer #1: But, amazingly, Luz doesn't seem a bit fazed! Why, he's springing back to his feet, and now he's cutting a grand arc with the sweep of his mighty right arm, stopping to jab his index finger at Sombra. Let's listen to how he's going to bounce back from that shot.

Luz: It is through suffering that we are able to obtain a deeper compassion and wisdom. Yes, this comes at a terrible price, but it's not easy being God, either . . . let me tell you! "Not only so, but we rejoice in our sufferings, because we know that suffering produces perseverance; perseverance, character; and character, hope. And hope does not disappoint us, because God has poured out his love into our hearts by the Holy Spirit, whom he has given us."

Announcer #2: Ladies and gentleman, with that said, Luz is scrambling out of the crowd and leaping over the ropes and back into the ring, running faster than a preacher from a burning whorehouse. And he's using his momentum to put a vicious clothesline on Sombras with his right forearm, dropping Sombras to the mat like a bag of rocks. I cannot believe my eyes. Talk about a comeback! I bet Sombras has just got to be blowing snot bubbles right about now!

Announcer #1: And, hey, I just heard the bell ring, so that's the end of Round 2. You have to wonder: Just how are these judges going to make up their mind and pick a winner? I can see the three of them conferring, and, meanwhile, the managers are in their respective corners, tending to their fighters. I gotta say here, this whole thing is blowing my mind! I just can't wait for the third and final round. (Bell rings.) And here we go!

Audience Member #3: Is God dead?

Announcer #2: Holeeee smoke, I bet nobody saw that one coming! I mean, who was that guy, who, if I'm not mistaken, is also wearing a mask? And just how are our two contestants going to handle that little hot potato? I tell you folks, the action here is riveting . . . this is one contest that is really living up to its billing!

Announcer #1: But wait . . . something's going wrong. Both fighters are looking up at the crowd, clearly puzzled.

Announcer #2: Yes, there appears to be some sort of commotion in the audience. Something is definitely going on. . . . Oh, my goodness, Modern Man is actually leaving the building. Yes, I can't believe my eyes! And the seats are emptying out as everyone seems to be rushing for the exits. Let's go down to our reporter at ringside and see if he can tell us just what the heck is happening down there!

Reporter #1: That's right, that's right. Everyone seems to be leaving the arena, just as fast as they can. The two angels are clearly upset and looking a bit bewildered right about now. I mean they can't figure it out either.

I tell you what, I'm going to step over here and speak to this young man, who is one of the people trying to get out of the building. He looks like he may be pretty ripped, but, perhaps, he can enlighten us about exactly what's going on. If everyone can just bear with me . . . I'm going to have to push my way through the crowd. Excuse me! Excuse me! It's getting a little crazy down here, I mean it's pretty much a stampede to the exits!

Sir, sir, could you please tell me what's happening?

Audience Member #4: Oh yeah, man, sure, like, How ya' doing? Hell of a fight going there, wasn't it? Well, I don't know about everybody else, but I thought this was going to be a Bob Dylan concert, 'cause, you know, talking about Judgment Day and stuff, didn't he write a song about that? Now that he's won the Nobel Prize, doesn't that mean he's a genius or something? I mean, especially since he didn't even show up to get the prize. . . . I mean, how cool is that? I mean, isn't that just like God, not showing up?

But, anyway, I guess none of that matters now, man, 'cause I guess I was mistaken. To tell you the truth, man, there's too much talking going on between these two hombres. I mean, I just wanted to see the dudes, like, hurt each other. You know . . . combat! And where are the babes—how's about a little T and A? At least throw in a few cheerleaders, for Christ's sake . . . oh sorry, not sure if I'm allowed to say that here. And finally, man, I like, just don't see any way this is going to have a nice, neat Happy Ending. So what's the point? Besides, if I really cared about all of this stuff, I can always look the answers up on Google, like in my spare time. Google knows all, man.

Announcer #1: And so all of us watching today's match will be left to ponder who might have won if the contest had gone to the finish. Who knows, maybe things can be worked out to get these two fighters back together if something big happens, like The Bomb or The Plague—after all, Sombra still lurks. Maybe then, people will care enough to take time out of their busy schedules to find out The Answer, but, for now, it looks like it's time for us to wrap things up here at the arena . . . guess "That's all, folks!"

THE ENCOUNTER

"When the student is ready, the teacher will appear."
—Buddhist Proverb

The reason for choosing *Black Bird* as the image to key this story is simple. The tree in this photograph was the only one for a very long way in any direction. I am certain that the black bird in this picture flew to this tree to examine me. He was curious and wanted to know what I was doing. He stayed perched in that branch for several minutes, cocking his head from side to side. In such magical moments, I feel much less alone, sensing the circle that binds all creatures in the fellowship of life. That bird and I had a *connection*, as did the creature who figures prominently in the ending to the following story.

"My son hates it here, there's too much sun. No shade. He's getting the hell out of here as soon as he can." A proud mother, slightly drunk, was telling me this at a cocktail party, explaining the escape plans of her seventeen-year-old son as he plotted his future. We were in Phoenix, and she went on to say that he was moving ASAP to San Francisco to go to school. From there he would proceed to that great Mecca of western civilization—where else but New York! Now from my perspective, both of them are wet, sticky places that are green and chock-full of people jammed shoulder to shoulder who are largely indifferent to one another. Oh, and it rains a lot.

She spoke to me as if only some idiot would not see the overpowering logic of her son's choices. In that moment in her mind we were co-conspirators, as she assumed we shared a mutual hatred of this place. I found myself thinking that the red of her lipstick was much too bright, and it was smeared at one corner of her mouth, giving her face a disquieting painted look (I had a terror of clowns as a child).

That last thought was all it took. Blink. I was "unstuck" from the conversation. Although I have not yet mastered physically traveling in time, in my inner world I'm a regular Billy Pilgrim, the protagonist in Kurt Vonnegut's *Slaughterhouse Five*, all too readily becoming unglued from such moments, at least in my thoughts. It is not a trait that I'm proud of; in fact, I find it annoying. But, with the passing of the years, I've become more resigned to it—perhaps even too comfortable with this means of escape. In my defense, it's the nature of consciousness, isn't it? Is the reality that we happen to find ourselves in at any one time any more "real" than the world that we create in our thoughts? Now, those individuals who are reading this and are practically minded will simply dismiss this experience as daydreaming. Fortunately, I am expecting that very few such folk will ever read this—they'll be out building dams (think here of beavers swarming over their latest project), doing homework, learning Mandarin and such. And, besides, I believe it to be a

near-universal experience to have awoken at night, relieved that it was "only" a dream—for, in that moment, the world created in that dream was every bit as real as any reality the author of the dream had ever experienced. It is the existence of dreams that leads me to believe that we are all storytellers, and that is the reason we all love a well-told story.

And that's how I found myself standing on the back steps of the Calipatria Motel in my mind. It was twilight, and I had an unbroken view of a flawless sky, with nothing to protect me from the yawning vacuum of space other than the preciously thin envelope of air that surrounds the surface of our little sanctuary that we call Earth. To the west, where the sun had recently set, the sky was a molten rainbow that began with a ruddy red on the horizon and evolved in an infinitely subtle progression over the vault of the sky to the cool blue-black of the eastern horizon. The thinnest possible line of a new crescent moon hung overhead, suspended by invisible wires from the infinite deep that hovered above it. It was as if the sky was a fragile membrane and some cosmic finger had carelessly brushed its substance, creating this delicate tear that I now experienced as the moon. It was almost too thin to perceive, its brilliance hinting of the blinding light from a perfect world that lay somewhere on the other side.

Of course, the moon had been there all along, hidden by the light of day. It was only here on the dark side of Earth that it dared reveal itself, trailing endlessly behind the sun.

The agricultural town of Calipatria was founded in 1914 as Date City and lies in the Imperial Valley southeast of the Salton Sea. At 180 feet below sea level, it's the lowest-elevation city in the hemisphere. (Does that mean it's that much closer to Hell?) It is announced by one red light at the crosshairs formed by the intersection of CA 111 and 115. There is typically little traffic, and most of the cars that are on the roads are clearly headed someplace else. Maybe to the nearby prison. Often, cruising through town (headed someplace else), one has to look very carefully to see a live person anywhere. Its peaceful appearance is a bit misleading, as the mighty San Andreas Fault runs very close by—with all of the threat of capricious calamity at any given moment that it represents. One can understand why there is a palpable "edge" here, despite its bucolic appearance.

Maybe the unease is the product of the wind that frequently scours the terrain, leaving a coat of fine white dust on anything that hasn't moved in a while (which seems to be pretty much everything in town). The town and its immediate surroundings are basically an artificial oasis located in a vast sea of barren, drifting sand, and, when the wind is right (and it often is), the air becomes dense with the pungent aroma of the local stockyards, as violent to the senses as that dead skunk smell unfortunate drivers encounter on the highway. Whereas the smell of a skunk on a highway is the smell of death, the smell that drifts over Calipatria is the smell of money, made by the owners of those stockyards, although I wonder if any of them have ever even been to this place.

In Calipatria and other locations like it in the desert, thoughts of eternity often begin to tumble in my mind. What is it about such places that they are imbued with such power?

Blink. Oops, I'm mind-surfing again. Sorry. Please, be patient. Besides, you've probably suffered through such ecstatic prose-based descriptions of the desert before, and can you honestly remember any of them? So now, come with me, and I will tell you a story. It's not a made-up story—it really happened. (I will duly inform you of those parts that didn't.)

It had been a bad week; you know, because you've had them yourself. This was so long ago, I can't remember what I was upset about. It might have been a million things—an argument with my then-wife (who is a wonderful person—no innuendo intended to the contrary), a boss who was an asshole, who knows? But I think it was because my father had just died a few weeks before, and I still just couldn't get my head around it.

I do not lay this latter possibility out so casually to be in any way disrespectful to my father. His death was personally devastating—something previously unimaginable to me that was my raw, sharp-edged reality at that time. There were moments when it was an effort to breathe due to the crushing weight of first-time grief. I cite my lack of certainty about what was going on in the interest of validating the corrosive effects of time upon my memory. As I grow older, I have been surprised that all that seemed so important to me in the *now* inevitably has become far less so when *now* has become *then*. Maybe that is because passion is for the young, but I don't think that's it. Time has a "fun-hall" effect on the world that we recreate in our memory. Instead of using mirrors to create illusions, it is a contraption devised from lenses—lenses that bend perception such that all that we have experienced grows less distinct and progressively less significant the further we travel from where we began, until all that was—inevitably—is no more.

And this is how I found myself cruising down Pinto Basin Road in the middle of Joshua Tree National Park. It is a thin, two-lane line of sun-baked asphalt draped like a thread from one mountain ridge to the next, stretching bravely, if tenuously, for some 20 miles or so before me with no sign of anything made by man other than the road itself. It seemed that even the Creator had lost interest in the place, as the landscape was mostly bare sand and rock, with an assortment of small, scruffy bushes and cacti that had somehow been doomed to eke out a meager existence here.

I had been driving for a long time and had not seen even a single vehicle, coming or going. I had the place all to myself. What would I do with it?

My first impulse was to speed up—it was taking such a long-damned time to reach that bare-assed hogback of a ridgeline that seemed to be perpetually moving away from me on the horizon. Especially since I was poking along at the 45 mile-an-hour speed limit that had been processed by some bureaucrat at a desk and then reviewed/approved by a committee back in Washington (in case you haven't figured it out by now, I was in a foul mood). So, what the hell! I got in touch with my devil-may-care, frontier-pillaging American ancestry . . . and smashed the gas pedal right down to the floor. Hey, baby, I was going to burn this road down! I had a need for speed!

Okay, that really happened—I did push the accelerator to the floor and waited for the surge of adrenalin that I imagined was about to explode in my body under the intoxicating effects of traveling far above the legally approved maximum speed limit. Yeah, baby!

But just my luck, I was NOT in a candy-apple-red Porsche 911 convertible road rocket with the top down. Instead I was in a rather uninspiring (although VERY sensible) 1978 (my present to myself upon the year of my graduation from medical school) Toyota Corolla (ahem . . . hatchback . . . I wasn't completely gutless) with a dinky four-cylinder engine. Even with the air conditioner off (truth is, in those days I didn't have one, because I couldn't afford that option when I bought the car), it was a mostly unsatisfying experiment with sociopathy.

So I got her (note here the subtle linkage of cars and women, which I can tell you, as a neurobiologist, is no accident, as the thrill of orgasm and the thrill of speed light up many of the same dopamine-based reward circuits in the brain) up to oh, maybe 80 miles an hour or so for a few seconds, but then quickly lost my nerve. It just felt so . . . wrong. I was having a bruising superego attack. It was time to retreat. Off came the foot from the accelerator, and, before I knew it, I was "legal" again, cruising along at 45. Oh, yeah. So, this is what a life of criminality feels like? Glad it's over.

Unfortunately, my state of law-abiding bliss was short-lived.

Maybe it was because of the randy mood I was in or too much coffee, but being a compliant member of society just wasn't working for me on that day. My mind began to search for

alternative means of expressing my new-found spirit of renegade defiance. But what can you do out in the middle of nowhere if speed doesn't get it? After all, I had very few tools to work with in this empty desert.

Then it came to me. In the right circumstances, going too slow can be every bit as outrageous as going too fast. And my vehicle was far more suited to indulge in this particular form of civil disobedience.

I furtively checked the road ahead, then looked in the rear-view mirror just to be certain that no one could see me (as you may have discerned, outlaw behavior does not come naturally to me). Thus reassured, I did it—I took my foot off the gas. Whoa! The thrill of it all!

It took a few seconds for the car to begin to slow down, in part because the vehicle was working through a shudder of disbelief at what was happening. To make matters worse, I was going downhill and, therefore, my faithful steed took a while to decelerate. That said, before I knew it, the speedometer needle was dropping. First it read 40, then 35; oh hell, you get the idea. Before I knew it, I was creeping along a piece of major highway right here in the United States of America at, like, FIVE MILES AN HOUR. Can you dig it?!

Trust me, don't bother. It wasn't much fun either, and I kept finding myself checking the road in front and behind me to make sure that nobody else was around.

So, creeping along the road at such a slow pace, I was still unsatisfied, my angst as yet undiminished. I was still looking for trouble. What could I do next?

And then the answer came to me. I would stop. Right here in the middle of the road, forgodsakes!

Now I'm stopped, sitting there in the middle of the highway, a circumstance so completely unfamiliar that it had a creepy out-of-body quality to it, despite the fact that I was utterly alone. That ribbon of highway (Arlo Guthrie, are you out there?) stretched ahead of me to the west, behind me to the east, and there was not a single other human being anywhere, in a car or on foot, to blemish my perfect solitude.

But even that maneuver just wasn't getting it. It still wasn't enough.

On an impulse, I opened the door, got out and stood there in the middle of the highway, my feet planted on the dingy white stripe that ran right down the middle of the road.

How to make it even more outrageous? Without willing it, those same two feet now began to transport me away from the car, as if they had a mind of their own. So maybe this was one of those mysterious out-of-body experiences, like Carlos Castaneda advocated as the pathway to enlightenment? I had become a terrestrial astronaut attempting an earth-bound space walk, each step carrying me further away from the safety of my little excursion vehicle and deeper into the alien, hostile landscape around me. I turned to look at my car, progressively growing ever smaller, sitting parked in the middle of a perfectly good highway. It seemed a bit surreal sitting there, with a sudden gravity to its presence that I had never perceived before. Would it wait for me to come back? What if it became disgusted with my bad behavior and just drove off? It would be a long walk back to civilization for me without it, and there would be some explaining to do—which might get awkward. I realized then my thoughts were getting pretty *weird*—maybe that whole Don Juan-Yaqui-Vision Quest thingy was really starting to happen!

Despite my jitters, I was still not satisfied—life with all of its frustrations and disappointments was just too confining, even out here on my earth walk.

Then it came, completely unplanned, unannounced. From deep within the darkest recesses of my soul, a great gas bubble of frustration, doubt, and fear came tearing to the surface of my psyche and erupted with a fury.

I screamed. Actually, the first time I did it, I just tried to scream. The sound that came out with that first effort was pretty pathetic to my way of thinking in that moment—it sounded way too plaintive. I knew the reason the sound had come out that way was because, even out here, I was still trapped by being self-conscious, having spent all of the years of my life up to that point as a model citizen, a paragon of conformity. I was fearful that, despite all of my precautions to ensure that I would not be observed, there might have been some momentary lapse in my attention or some critical detail I had missed, betraying the existence of another person in this world. This would then lead to a moment of complete mortification as soon as I did such a foolish thing as scream my lungs out in the middle of nowhere with every ounce of effort available to me. Inevitably, someone would pop out, previously unnoticed but miraculously now present to witness yet another occasion in my life when I was weak and humiliated. I would make a fool of myself—again.

But no one was listening. Or so I thought.

This time the bellow that erupted from me was great and primeval. I held nothing back as I took my deepest possible gulp of fine desert air and then locked my rib muscles down hard to create a mighty blast that crossed the reeds of my vocal cords on its way back out into the world around me. I was thrilled, for I had summoned a full, throaty roar for everything I was worth. I had begun with my head pointed at the sky, but then progressively bent further over to the earth as the great convulsion of effort seized me. I roared until I had no more breath, and my face was in my knees. This was not some pathetic little spirit-fart like the first go around—this was awesome, validating! I had discovered the thrill of anarchy, sweet abandon.

It was all so gratifying . . . so much so that I did it again.

I ripped off another of those soul-draining primal scream outbursts, this time even mightier than the first, for I had the benefit of having practiced. Wow, I was *living* (to paraphrase Forrest Gump)!

Only this time, instead of being met with total silence, I heard a faint rustle of movement, located about thirty feet to my left. My immediate reaction was "Oh, my God, I've just made a complete ass of myself, and someone really was watching!" The horror! But it wasn't *someone*. It was *something* . . . or maybe it was someone, as subsequent events would suggest.

The creature that had moved was a very large, very perfect jackrabbit. Maybe the biggest, finest jackrabbit I had ever seen. My first reaction was one of amazement—it was so close, perhaps only 20 or 30 feet away from where I stood. I did not want to do anything that would startle it, make it run away. But then I realized that Mr. Jackrabbit wasn't scared of me at all. He was . . . puzzled . . . curious. Just what was this crazy human being doing out here anyway? I guess he figured that anything acting so bizarrely, with absolutely no pretension of stealth, could not be harmful or represent any kind of threat. Nope, this two-legged being (me) isn't dangerous—he is crazy.

It loped rabbit-style very slowly from behind the creosote bush where it had been watching me. Examining me. We made eye contact—stared into each others souls. Mano-a-mano. We were having an interspecies mind-melding encounter. I could see the twitching of his pink nose, the scanning motion of his whiskers. He had enormous ears, held now in a half-cocked, relaxed position. He clearly didn't feel threatened but also wasn't going to take too many chances and let his guard down completely. After all, he was having an encounter with a two-legged creature, and even a crazy one might be dangerous, given how many rabbits humans had eaten over the millennia.

And then I watched in amazement as he rose to his hind legs and stood erect. As he did so, he also began to grow in size. Why, in a matter of seconds, he was transformed—going from a plain-old jackrabbit to a colossal beast, standing maybe eight feet tall, not even counting those enormous jackrabbit ears. Although I had failed to see it before, I now realized that he had a large,

rather stylish cowboy hat (white, of course, which told me at a glance that I had nothing to fear, as this was a "good guy"), most likely a fine Stetson, perched on top of his head. There were two holes punched through the brim to accommodate those big, floppy ears. And because he had grown so much in stature, he now seemed to be right next to me, his commanding figure looming above me against the sky. It was then when I realized that I had not conjured up merely a jackrabbit, but a pooka. Why, maybe this was Harvey's cowboy cousin, standing right here in front of me! (For those of you too young to remember, Harvey was none other than the famous pookah who appeared to Jimmy Stewart in the eponymous film, *Harvey*.) He then cleared his throat and in a deep baritone voice said, "Things ain't as bad as you think, partner."

You will likely have already inferred from that quote that he had a definite cowboy drawl, and you would be correct. "As you may learn from the way in which you are now perceiving me, things are only as big or small as you make them."

And even though he had just said a mouthful with that last statement, he wasn't letting up yet. He then went on to quote none other than the Buddha himself. He said, still in that drawl: "In the end these things matter most: How well do you love? How fully did you live? How deeply did you let go?"

With that, he dropped back down on all fours and slowly ambled away from me. He went back around that creosote bush from which he had appeared, and—just like that—my Buddha-quoting, eight-foot-tall supernatural being was gone. I was alone again.

My head still buzzing from what I had seen, I headed back toward the familiar world represented by my car. I opened the door, slid into the seat, and turned the key in the ignition. It started easily (it was, after all, a Toyota). The familiarity of this action, and the fact that I had done it a thousand times before with exactly the same result, was reassuring. I slipped her into gear and began rolling down the highway once more.

And, to tell you the truth, nothing described above after the word "millennia" really happened. I told you that I would tell you the truth. Everything else before that did occur, in just the way that I described.

In that moment, I was at peace—for, after thinking about it, I realized we are never alone.

LONGING

"Those who restrain desire, do so because theirs is weak enough to be restrained."
—William Blake, *The Marriage of Heaven and Hell*

Early one Sunday morning in El Centro, I happened upon two young men talking to each other along a railroad line. Although I feared they might be hostile when I approached them, they were actually quite friendly. One of them (who appears in *The Searcher*) told me that he "wanted to see the world" and so was "homeless." He continued with obvious pride that he had been to the bottom of the Grand Canyon, walked across the Golden Gate Bridge drunk, and lived on the streets of Manhattan. He'd been arrested in 14 states but had "never stolen nothing and never told a lie." In the photograph, he is looking at the horizon. It is his home.

The other young man was a musician. He told me that he dreamed of performing some day in Nashville. I know two other things about him: that he lived with his elderly grandmother, who sold cosmetics, and that he wore a shirt with a pattern of many stars. He appears in the triptych, *Shirt Full of Stars*.

Both young men were restless, yearning for something they had not yet found. The fictional story that follows is a fantasy inspired by my respect for their search and the few facts I know about the young man who aspired to be a musician.

"What do you want?" is a simple enough question, but sometimes it's so hard to know.

The person asking this question was an elderly Hispanic woman with some ninety-three years of life to her credit. Lita's bones were ancient and complained bitterly whenever they were forced into action, no matter how trivial the motion. Even the simple task of bending slightly forward at her waist to lean over and talk to her dog required some effort. She had learned that, at this stage in life, nothing comes easily, not even the smallest of movements.

Aji sat patiently at her feet; she knew the drill. She cocked her head just so, perked up her fruit bat-like Chihuahua ears, and above all established eye contact with whatever human was the current object of her machinations. At 14, she, too, was old and wise and knew just what it took to get what she wanted from her two-legged masters. They were as putty in her paws, especially if she could get the eye-contact thing going. Her brown eyes now deepened and became dark, limpid pools of desire, irresistible to any human foolish enough to stray into the hypnotic spell that she conjured with her stare. Aji longed to be indulged and was consumed by the thought of just how wonderful a piece of still-warm, fresh-cooked *cerdo* (pork) would taste upon contact with her palette. How marvelous it would feel as it glided down her throat and plopped into her small but insatiable Chihuahua belly.

"Now *that* is satisfaction," Aji thought to herself. She just had to get that eye contact going, working the magic.

Lita gave a sigh and affectionately mumbled, "You bad little dog, you are such a *seductora!*" She threw her a small scrap of fat from the pork that she was preparing.

The morsel cut a neat, silent arc downward through the air, but it would never touch the floor. Aji's little jaws snapped open and shut with expert precision, making a succinct *thwup* from the rush of air created as her mouth sprang open, then clamped shut, like a miniature bear trap.

There followed a quick gulp, then a satisfying circuit of her quick, pink tongue to lick her chops and seal the deal. Just that fast, and the treat was gone. It was then as if it had never existed, requiring but a second or two to complete the entire cycle: *longing-gratification-longing.* Aji reloaded the pleading expression on her face, figuring that, if she played her cards right, there would be even better things yet to come from whatever was happening up there on the kitchen counter.

Lita turned away and resumed shredding the pork. She was making enchiladas for her grandson, Alejandro. She would serve them with big helpings of beans and rice. She was even making sopapillas, to be served dripping with butter and honey. The aroma of the frying dough filled the room, like ambrosia. These were all of his favorites. But in contrast to the sense of celebration implied by the preparation of such a feast, her heart was, in fact, quite heavy. She wanted it to be a special evening for him, one he would never forget in the years to come. This was not totally unselfish, for she secretly hoped that the memory of this meal might haunt him—lure him back to her some day with such force that he would never dare leave again.

She was distressed, because tomorrow morning would bring an event that she had dreaded ever since 'Jandro had told her of his plans. She had not seen it coming—the sudden announcement that he was leaving on a bus in just one week to some faraway place called Nashville. He told her he was going to quit his job washing dishes at the café (the same restaurant where his mother had worked, years before) and follow his dreams before he got too old to remember them. After all, the town where they lived was just a forlorn, forgotten little place, slowly but surely shriveling up and dying out here in the seemingly endless desert. There was just a single exit on the interstate at the edge of town, since no one ever came or left. For 'Jandro, this town was like sticking your fingers in one of those Mexican finger traps. Oh sure, it was easy to get yourself caught here, but the only way you were ever going to get out was to know the secret of how to escape—and no one seemed to know it, or, if they did, they sure weren't telling him. But, in Nashville, things would be different. There he could play his music and maybe one day become a big star, someone that everyone admired.

"*Tu es loco en la cabeza!*," Lita had loudly protested after hearing of his plan. The thought of losing her only surviving family member to such wild dreams appalled her. 'Jandro had always been such a sweet boy and had never talked about doing such crazy things. Why, he had never been further away than San Diego, less than a hundred miles from home.

She smiled to herself, when she remembered what a dismal failure that first expedition beyond the city limits had been. On that day, when 'Jandro was about eight, she had taken him to the world-famous San Diego Zoo. Upon getting there, just as soon as 'Jandro spotted all the crowds of people, he began crying. He was inconsolable 'til his Lita promised to take him back home—now! But that was then, and this was now, and something she did not fully understand had obviously changed in the interim, profoundly. He had not spoken of leaving since that adventure, until the dreadful day of his announcement.

At the time, she had begged, pleaded with him, "Why? Why, *hijo* . . . do you talk so about leaving me now? I am old, how can you do this to me?"

On that day, he would yield no answer, just the stubborn, almost pleading response, "I just have to," over and over again. Lita understood that, in part, his apparent inability to answer her question was the fact that he was young. The young are often driven by primal desires, which they only dimly comprehend. To that add the fact that he was, after all, a man. This subset of the human race was indeed capable of great emotions but, for the most part, endowed with very little awareness of them, much less the ability to articulate them. Youth and male gender: a volatile elixir, which, when shaken, is inherently unstable, combustible—even chaotic in its energy.

In reality, although 'Jandro was a musician and, therefore, presumably a minstrel of the soul, even he did not understand the forces that were driving him to leave—for somewhere, anywhere. He just had to get out of this town—now! Washing that endless pile of dishes at the Café Contento was killing his soul, one dish at a time. He imagined himself lying crushed beneath the great pile of dishes that he had already washed and the even higher pile that was yet waiting for him in his future. Was this to be his legacy? No! 'Jandro longed for some measure of fame and fortune.

And, so, the result had been that Lita was now left preparing this meal—their last supper before his departure. Just then, 'Jandro walked through the door. At the age of twenty-two, he was a handsome young man, with straight, jet-black hair and the dense stubble of a five-o'clock shadow grown blue-black upon his face. His skin was unusually pale. When set against his raven hair, the black-on-alabaster effect was quite startling, even to casual passersby. He was thin and seemed frail—kind of a sickly boy. Jandro's father had been only eighteen himself when 'Jandro was conceived. Upon learning that he was to be a father, he did two things: He promised 'Jandro's mother, Maria, that he would be back the next day with a ring; and then, on the way to the jeweler, he joined the Army—and was never seen or heard from again.

Even his mother was but a vague memory to Alejandro. She had wanted to be a singer and longed for the chance to make a start in a different life. But, in their town, no one took her seriously. For several years after 'Jandro's birth, caring for him had been enough to satisfy Maria's longings, but then there were the endless, dreary shifts at the Contento, where she worked as a waitress and could see no horizon at the exhausted end of her days.

On one of those days, a stranger walked into the café, an older man named Nick—widely regarded around town as a bit of a shady character, as it was well known that if you wanted to get high, he was the man to see. Nick was a Cajun boy from Thibodeaux, Louisiana. He had dropped out of school to become an oilfield roustabout who longed to see the world. He was living the dream, until it had abruptly come to an end in an oil-rig explosion. In its aftermath, he was left as the proud owner of several severely fractured vertebrae in his cervical spine. His life was forever changed, and he drifted steadily downward in a haze that was the perfectly locked circle of pain and narcotic drugs to make that pain bearable. He longed to be made whole again, free from the terrible suffering that afflicted him. That time came but not in the manner he had anticipated.

Maria was initially enough of a distraction to help Nick escape from his agony, especially when combined with a pinch of this and a little bit of that. She was a sweet kid who almost seemed to want to mother him somehow, but that frustrated him. The vulnerability that came with dependence upon another person served to heighten his insecurity. Such are the instincts of a feral animal.

For her part, Maria both admired and feared Nick. He had lead a life she could only have dreamed of, living in all of those faraway, exotic places. His body was emblazoned in a dense matrix of scary tattoos from the neck down. He told her that with each tattoo he had made a secret vow to give up something he liked in exchange for a special power—that lasted for only as long as he kept the vow. One tattoo was particularly frightening—that of an enormous spider, sitting upon its web astride his back. Whenever Nick moved, the spirit locked in the tattoo, which

was very powerful, created the illusion that it was crawling, as if it were descending upon some prey—the latest victim unfortunate enough to have strayed into its web.

At first, the tattoos had indeed imbued Nick with great potency, but when his spirit became broken by the grinding persistence of his affliction, he had broken one sacred vow after another. In the end, the spirits that dwelled within the tattoos deserted him, even that of the ferocious spider. That one was the last to leave. The designs upon his skin became reduced to nothing more significant than so much graffiti upon a crumbling facade.

The use of heroin had started innocently enough. It gave him relief from his pain, and he wanted Maria to try it with him, suggesting that somehow it would make them closer. In reality, he was hoping that its use would make the sex wilder, more ecstatic, and, besides, he so longed for an escape.

"Just try a little. It won't hurt you. Besides, it would be fun to do it together . . . trust me," he had said in his low gravelly voice, reduced at that moment to something like a purr.

And, so, after a few weeks of such recklessness, they were discovered by neighbors on the floor of his apartment—dead. They had been skin-popping heroin for several days, and, on this evening, the bill for their behavior abruptly came due. Intoxicated, they had continued to dose themselves. On that night, Maria got out of town for good, although, unfortunately, she was not conscious enough to savor the moment.

As for Nick, his last thought forever would be one of remorse. He had been conscious just long enough to realize that neither of them was going to get out of this alive—that the spider must have somehow returned, unrestrained, longing for vengeance. Nick was now just one more despicably weak human being who had broken his vow. For himself, he didn't particularly care, but he felt bad for Maria. His embrace had proven to be no different than that of the enormous spider he still carried upon his back. He had killed the only person who ever unselfishly loved him, and he longed to have been born different, worthy of the love of another.

These were the forces that were propelling 'Jandro to act, even if blindly, with such desperation. Every dish that he washed added just that much more mass to the great, dark vortex that was rising within him and inexorably gathering strength, threatening at any moment to swallow his soul. It was the same dark energy that had taken down Maria and Nick. Although he knew the facts of what had occurred to his mother, he was oblivious as to how this knowledge had affected him. And so he bluffed, weaving a tale of departure that was motivated by hope rather than fear.

"How was your last day at work, *mi corazon?*" Lita asked.

"Oh, it was alright. They just gave me my last paycheck, and we said goodbye." Being a male, this was all that got said. He did not tell her of the tears or the kind, poignant memories the owner of the Contento had shared about Maria.

The conversation at the table staggered awkwardly onward, as neither was sure what to say. The moment was fraught with too much significance to talk easily, so Lita asked perfunctory questions like "How long is the bus ride to Nashville?" and "Where do you plan to stay once you get there?" After a few minutes of such meandering chitchat, she abruptly switched tactics.

"Why? Why, my son, are you doing this? This is not going to work . . . you are throwing your life away. Why don't you go back to school and get a degree, so you can get a *good* job? I know you don't want to spend the rest of your life just washing dishes! I get that . . . but this? I will miss you so!"

'Jandro's eyes dove to the floor. He was aware of his deep sense of guilt, inspired by the prospect of leaving his beloved abuela. Were it not for her presence in his life, he would have become an orphan, unloved, perhaps even worse. For this he had a profound sense of gratitude

and the obligation that goes with it. He also knew that, upon his departure, she would truly be alone, with only the fellowship of her faithful Aji to sustain her.

And so he told her of his plans. "Lita, when I get to Nashville, I will work hard and save all my money. One day, some big shot with a fat cigar will be sitting in the audience, listening to me perform. He will sign me to a record deal, and I will make a lot of money."

"'Jandro, how many kids do you think go to this Nashville, with the same dreams? And how many off them ever make it?"

Even as she said it, Lita hated the impulse on her part to puncture his balloon. He was so excited! And yet she felt it almost as a duty to warn him of the disappointments in life that might be coming his way in the years to come. She knew this only too well from her own life.

"I remember the gringos have a saying," she continued. "If you want to hear God laugh, just make plans."

Talking in this way also made her uneasy. She knew in her heart of hearts that she longed not to be left alone in this world and worried that her advice was self-serving. She then determined that she had just taken her last, best shot at getting him to change his mind. She would say nothing more of substance and, retreating inwardly, resolved to herself only to listen and make small talk in the conversation, so as to be courteous. She could clearly see that his mind was made up— that the line of inevitability had been crossed. So be it.

'Jandro was no fool. He knew his grandmother was very wise and grasped the truth of what she said. But, on this evening, it was not the truth that was his muse; it was his dream.

'Jandro misunderstood Lita's silence for acquiescence, and so now his words came tumbling out, as he was excited by the prospect of finally telling someone his long-suppressed fantasy. "Lita, when I get my first Cadillac, you know what I'm going to do, soon as I get it? Why, I'm going to drive that shiny new car all the way back out here—and come get you. One day soon, you'll see, there will be a honk outside your front door, and I'll be sitting there in that *fine* set of wheels, pretty as you please, just waitin' for you to jump on in beside me. I'll get Aji her own special dog seat so she can see out the window, with her name embroidered on it in gold letters. Then we will be a family again, back in Nashville." He pointed emphatically in the general direction of the door, as if the Cadillac was parked there, in the driveway, waiting for them at that very moment.

For her part, Lita knew that such talk was foolishness. She also knew that he needed to believe this could happen. And so she laughed, then sighed, as if she was getting with the program. That is how much she loved him, for she longed for him to be happy. And that was pretty much where the conversation ended, with talk of 'Jandro's Big Dream.

They left the table that evening, each preoccupied by thoughts of very different worlds. For her part, Lita had her own fantasies about the future—the future that would start tomorrow. She imagined how awful that moment would be, when she shuffled back home from the bus station in the morning and opened the door to what? To nothing! Just her little Aji. She could picture Aji circling around her feet, wondering when 'Jandro would be coming through the door. Never! Or at least she was sure it would wind up seeming that way in the long days that lay ahead. It was a bleak vision of what was to come, but she consoled herself that, over the years, she had endured and survived much worse. All that she had ever longed for was a big family—a house full of grandchildren to spoil for a few years, and then she could die happy. But it was not to be. 'Jandro was leaving, and, with him gone, there would be only herself and Aji to keep each other company and grow yet older together.

"*Asi es la vida!*" she thought. And although she knew she would miss 'Jandro fiercely, above all else, she consoled herself with the thought that, perhaps, in Nashville he would be happy. She

genuinely wanted him to be happy, whatever befell her. For that is the generous nature of true love—it gives inexhaustibly, expecting nothing in return.

As for 'Jandro, he excused himself and went upstairs to put a few last items in the duffel bag that he would take with him on the trip. He jumped into bed and turned out the light, but not before taking one last look around the comforting familiarity of his own bedroom. There in the dark, with nothing to distract him, the doubts welled up from within him to fill that black void that was the space between 'Jandro and the ceiling. For starters, he was aware that he was terrified when he performed in front of people—a rather necessary predicament in which he must repeatedly place himself if he was to succeed. There were also the nagging worries about where he would stay and whom he would meet. He had heard many stories through the years about how dangerous life is in big cities. But all of these concerns were relatively minor, as 'Jandro had long ago reached the point where his longing trumped any doubts raised by fear. Besides, he was young and naive enough to trust that, if he behaved himself and worked hard, he would surely succeed. He still believed that life is fair.

The more difficult problem that tormented him was the nagging guilt he felt about leaving his grandmother. He thought about the rich complexity of longing—how different people want such different things, and even when they want the same thing, their motivations could be so dissimilar. He wondered, why do some people act on what they desire, whereas others only dream, perhaps for a lifetime—like an itch they refused to scratch, even just a bit, fearing it would only grow stronger and consume them? And why did some people age into a place so far from where they told themselves they were going when their journey began? And then he remembered the adage that one must be careful what one wishes for—because sometimes you get it. And why is no one ever satisfied? It seems as if as soon as one object of desire has been achieved, it's on to the next. He had heard of perpetual motion devices; it is as if humans are perpetual *longing* devices. And how can two people who love each other want such different things, as was the case now with him and his grandmother? And, there in the dark, 'Jandro then blundered with maximum force into a peculiarity of the experience of longing that has no doubt tormented humankind for eternity—that it is possible within oneself to long for two opposing choices that are, by their nature, mutually exclusive—each with equal conviction. How could he take care of Lita and yet follow his dreams? There was no answer. Eventually, he fell asleep.

The next morning, he awoke in the predawn darkness. He leapt from bed as soon as the alarm sounded, as eager as a racehorse, thrilling to the sound of the starting bell. He reached into his closet to grab his favorite shirt, the dark blue one ablaze with a pattern of rows and rows of tiny white stars . . . so many that they formed a universe of hundreds, if not thousands, of such stars—each one a token of a separate longing that one might experience in life. He slipped into the shirt and finished dressing, then picked up his duffel bag and guitar.

At the bus station, he hugged Lita one last time. In the years to come, he would learn that it is often the longing, not the having, that is the finest part of life. But that was a lesson for another day. He waved goodbye to Lita as the bus pulled out of the station. At last, he was on his way. The town disappeared. He thought about the song by Jimi Hendrix, *Hear My Train a Comin'*, especially the last few lines—"I'm gonna buy this town an' put it all in my shoe . . . might give a piece to you." He wondered if things had any chance of turning out the same way for him.

Lita had looked so very small standing beside the bus, and she grew ever more diminutive as the bus made its way. Finally, he could see her no longer.

They would never meet again.

DEATH—IT'S JUST LIFE

"Why should I fear death? If I am, death is not.
If death is, I am not."
—Epicurus

The desert easily lends itself to thoughts of death. Perhaps it is the tenuous nature of existence here, where all of life is only as good as its last drink of water. Maybe it is because one often finds bones lying about. The lack of moisture seems to exert a desiccating effect that inhibits decay— seems like even the bacteria have a tough time making this place work for them. Or maybe it is that constant view of the horizon, which always seems to be lurking, or the desert skies at night, filled as they are with stars. These set one's mind to thinking about how very small we are.

I chose to pair this story, which begins with a fictional account, along with the image *Yucca Boulevard, El Centro*. The vase of flowers in the picture has a strained gaiety, despite the bright colors, what with all of the shadows closing in on it. The flowers are typical of the faded artificial flowers one often finds on graves, placed there by loving hands, guided by wistful memory—both flowers and memory dimmed with the passage of time.

All of us have to learn how to live with the knowledge of our mortality. In my experience as a physician, people do so with widely varying degrees of success. The old ones, their bodies crippled up with everything from arthritis to Parkinson's Disease, must confront the reality of death most starkly. For some of them, death becomes their friend—an event they welcome as an escape from suffering. Others go kicking and screaming all the way, afraid of the uncertainty. On that issue, it seems to me that if those who believe in an afterlife are right, then we're just changing form; if they aren't, we're going to sleep. I enjoy sleeping. The only vision I fear is that of the "wrath" crowd, which seemingly can't wait to send somebody to Hell. In my experience, my preference would be to spend eternity wherever these folks are not, wherever that puts me.

All of this reminds me of the image, *White Line Fever, Barstow*. It's 3:00 a.m.; we're sucking down hot coffee or whatever else will keep us going, driving down the road, hair on fire. The world is dissolving into a blur as we grow weary, our senses failing. Thousands of miles are behind us, and there is no certain place to go or time to get there. We're just driving, because that's what we were made to do. See you on the other side. Maybe.

"Doc, after everything that has happened in these last few weeks, for the first time in my life, I'm really afraid of dying."

The person sitting across from me in the room saying these words was a tall, lean older man in his early sixties. In recent days, he had come as close to dying as one can do without crossing The Big Finish Line. For, on just another ordinary day, an extraordinary thing had happened to him.

It had begun uneventfully enough, with absolutely no clue of what was to come. As it was Sunday, he had turned on his television to watch the Saints football game. He was having a late breakfast, as had been his custom on this day of the week for many years, even before retirement. He had fried up a couple of pieces of bacon and then cracked two eggs and watched as their contents spread lazily outward in the frying pan. He enjoyed watching as their margins seized up bright-white, where they contacted the hot metal of the pan. He savored the perfection of the moment—the contented burbling sounds of the eggs frying in the pan, the wonderful tangy aroma of the bacon that filled the kitchen, even the familiar noise that was the indistinguishable chatter of the commentators droning away in the next room ever so seriously about the *game* of football, as if any of it really matters. It was all good.

Somewhere near the middle of the second quarter, destiny came a 'calling. Upon arrival, she was only a whisper—he felt as if the grease from his meal had made him queasy, and he became aware of discomfort in his chest. Initially, the sense of pressure was barely noticeable, but it steadily grew until it was as if an elephant was on top of his chest, crushing the life out of his body. His first instinct was to rationalize what was happening to him: that, perhaps, he was only the victim of a particularly recalcitrant moat of bacon that was not going down without a fight. Reluctantly, however, he was smart enough to soon figure out that, this time, something might really be wrong. He called 911.

Before he knew it, he was in a local emergency room, feeling naked and vulnerable in a flimsy hospital gown, balancing upon the surface of a very hard gurney. The bright lights above him were uncomfortably intense and made him feel even smaller, like a curious specimen illuminated upon a microscope stage.

At first, the faces of the doctors and nurses had been casual and relaxed. After all, it was just another Sunday afternoon, and here was just another old geezer with a bad case of indigestion. As per protocol, they had ordered an electrocardiogram, just to be safe. The twitching needles of the instrument had branded the story of what was happening onto the graph paper that raced beneath them—a full-blown myocardial infarction (heart attack) was in progress.

No one was smiling any more, as the staff of the emergency room flew into action. Seconds were now precious while the team inserted a large-bore intravenous line, drew blood, and hooked him up to all manner of devices. Everything somehow seemed unreal, faraway, as if it was happening to someone else—the grim faces of the doctors and nurses leaning over him, his necessary helplessness and passivity in this moment of extreme peril. His body seemed no longer his own. When he looked down toward his feet, it was as if he had been transformed into some type of grotesque medical *piñata*, with intravenous lines and monitor leads attached to his form.

His last thoughts were spent wondering if he had remembered to trim his toenails recently and what the staff might think of him if he had not. He smelled coffee from the Styrofoam cup someone had set near him and stared at the light in the ceiling above him. It was not inert; it was *alive*, radiating energy into the room, bathing him in its glow. Each such detail filled him with nostalgia, for the ordinary had just become extraordinary, sublime. It had begun to dawn on him that this could be it! *Finis.* And he thought: I could be leaving all of this behind and, at any moment, put the next foot forward—only to crash through the floor. How curious. Is this what it is like to die? He wondered if he had left the milk out of the refrigerator back home, paid his electric bill.

It all seemed so distant, so very strange. He had become a detached observer, even as he was succumbing to the darkness that seemed to rise up from his being and engulf him, a force like that of an irresistible undertow. It was more like falling, really . . . and he was gone.

He would not awaken for three days.

And just who is this person to whom I have introduced you at this crucial moment in his life? He is brilliant—a man showered with all manner of academic honors when young, and one who had a long and successful career in the years thereafter. He had attended religious services, dare I say it—religiously—on a weekly basis for all of his many years. He gathered regularly with others of his kind in strict observance of the great holy days and mumbled the words of prayers that he had repeated endlessly since childhood. He regularly gave, generously, to charities in support of one worthy cause after another. He was viewed as a pious, honorable man, a pillar of the community. And yet he had a secret: He did not believe.

I mean, he didn't just have doubts; he flat out did not believe. Such an absence of any belief was the unfortunate outcome of his fierce intelligence, coupled with a dedication to an unflinching search for the truth, wherever it might lead. And so he had said all of those prayers, given all of that money to righteous causes, and, still, could find no solace. The best answer he had found was distraction, burying himself in a career, an active social life, and somewhere along the way, an unfulfilling marriage that inevitably lead to divorce. Despite his outward appearance of piety, all the while he felt like an impostor, hoping for some epiphany. It had been an act, like whistling in the dark.

"Fake it, until you make it!," the saying goes.

And that Rube Goldberg device to scaffold his soul had worked well enough, until now. For even the experience of his recent brush with death had stubbornly refused to yield any clues. When he sat in the chair across from me, he seemed so vulnerable with his uncharacteristically disheveled clothing, slumped posture, and downcast face crowned by a mane of thick hair colored just a shade too black, as if such a ruse might fool anyone other than himself. Unlike others who had been through this experience, he could recall no tunnels illuminated by a mysterious light at the end, or even a kind, reassuring heavenly hand reaching out to escort him to the Promised Land. Nor had the ghost of his deceased mother, whom he had dearly loved, come calling. There had been only Darkness, and he was troubled, now having to confront his own mortality.

His thoughts were a jumble of fear and questions. "When I go to bed at night, now I am afraid. Am I going to wake up in the morning? Dying, just what happens? Will I no longer exist? What was my purpose in life, what did it all mean?"

As a physician, it's a peculiar hazard of the profession to witness many people die over the years. I have had no great epiphanies from such experiences, other than how tenuous is the line that exists between life and death. It is amazing how adaptive and resilient life is—until it isn't, like a rubber band that, when stretched, abruptly snaps or a balloon that unexpectedly pops given just one puff too many. Take one wrong step (literally, not metaphorically), inhale as you're chewing/laughing in the same instant, or simply be at the wrong place at the wrong time—and the next thing you know you're dipping an oar in the River Styx. Nonetheless, I often get asked questions about death, as if they taught this stuff in medical school. You know, somewhere in the second year of studying to be a doctor, you're plowing through all those mountains of facts about subjects like microbiology, pathology, and pharmacology, then suddenly, *Whoop, there it is!* Yessiree, on page 377 of that impossibly thick textbook with the blue cover, sitting right over there on my desk. There you will find the answer to all of these questions, plus many more. But that is confusing knowledge with wisdom, for there is no such book, or if it exists, it was never handed to me. In fairness to my patient, he was smart enough to know all of this, but, goaded by recent events, he was now desperately back on the trail of the search for answers.

I have never been good at bluffing and do not feel comfortable with remaining silent. So I told him the truth. I do not know *The* Answer, and that is all I can say in this setting, in my role as physician. I listen respectfully and offer as much support as I can with well-meaning banalities such as "Have you considered discussing these questions with your spiritual counselor, talking with friends whom you trust, and finding out what they think?"

But, truth be told, I think I do have *an* answer, one I see most clearly when I am in the desert. That is the reason I return to these dry, desolate places. I am like a moth to the flame, drawn by the ineffable mystery I find made real here, and I find peace. Here is where I can see the wisdom of death and, if only for the moments that I am there, have little or no fear.

Now, before I launch into this any further, let me acknowledge that, most of the time, I'm just as afraid of dying as anyone else. I don't want my life to end any more than you do. Why, I just got the creeps as I was repetitively typing the word "death" so many times. I mean, who wants to think about this topic? But we all do it. Each of us is endowed with this gnawing awareness--no matter how fully we have lived, death awaits us, hovering just beyond our range of vision,

patiently, ears pinned back,

silently, crouched down low,

stalking each of us

with a calm certainty borne of the inevitability of success. Then pounce and . . .

<div align="center">GAME OVER!!!</div>

Now, I do not claim to be some bearded ascetic, lying on my deathbed somewhere on a mountaintop, uttering such Zen-pearls as "Death is just this and nothing more" (as I listen to a chattering squirrel somewhere outside the room where I now lay dying). Okay, I read that in a book of wisdom. Which I lost. Perhaps that is why I am not indifferent to our shared burden.

What I am certain of are two great principles of our existence that I see embodied in the desert. Taken together, they make death actually make sense: that resources are finite, so there's room for only so many of us at any one time on board this planet; and, secondly, through some tragic flaw in our design, often only that which is in short supply can be perceived by us as precious.

To develop the first of these principles, I turn to the philosopher Thomas Hobbes, who noted that Earth was stocked with only limited resources to make our journey through this world. And so, to survive, each of us must compete with every other living thing—from prions to blue whales. This is presumably why we bite, scratch, and claw so viciously to create and defend our "space," even (especially?) with our fellow man. In such a world of limited resources, there is only one way to make room for new life: that which has existed heretofore must be no more, to make way for our young, so that they, too, may enter this world and be granted a life, to do with it as each will. Modern efforts to prolong life greatly beyond its natural cycle seem greedy and self-centered—like someone who won't get off the roller coaster or Ferris Wheel at the carnival, even though they've already gotten to ride it a bunch of times.

Now, time for true confessions. I actually had the conceit at one time to think that this was an original thought, that no one in the history of our species had discerned this principle before me. As I now contemplate these words, I am a bit embarrassed by how silly that sounds. But there was one day, paradoxically as I was flying from San Diego over the desert on the way home to New Orleans, when I happened to be laboring through a 2,000-year-old poem by Lucretius entitled *On the Nature of Things* (as translated by A. E. Stallings). There, in Book I, lines 262–63, is a

powerful statement: "Nature refashions one thing from another and won't allow a birth unless it's midwifed by another's death." Okay, equal parts humility and epiphany here. As for the humility part, I realized that this (dead) guy said it better than I ever would and had figured it out long before I did.

Fortunately, there was also the epiphany to help the bitter part of the medicine go down: the thrill of sensing that Lucretius was whispering over my shoulder, as if he were there on the plane in the row behind me, still dressed in Roman garments. (Hey, just for kicks, let's put a long, flowing red robe on him and maybe even a helmet with those rows of bright red bristles on top, like in a Cecil B. DeMille film). A fellow pilgrim had somehow found a way to break free from the chains of time and come to this place far in his future—talking just to me, at 37,000 feet, no less. He was saying:

Each of us must surrender our spot as an act of love for those that follow.

As to that second principle, about shortages and our ability to regard something as valuable, it is a crying shame that we humans just cannot seem to value anything that is not in short supply. Let's take a drop of water, for instance. If one is holding a drop of water in their hand in the middle of a vast ocean where there is an infinite supply of its brethren, it becomes meaningless—perhaps even an annoyance. But place a single drop of water in your hand in the desert, especially when you are dying of thirst and there is not one other drop to be had, and it is transformed into something awe-inspiring . . .

Precious.

And *now* we can think only of our wish to have so many more of these, for that one drop has become treasured, and we are obsessed with the mystical beauty to be discovered in it, even as it reflects our own image back at us. One can estimate that there are 1.67 sextillion water molecules in that drop. Is its existence not a miracle? Are not the days of our lives equally so?

As I have shared, I do not claim to know what, if anything, lies for us on the other side. In many ways, death is like the horizon line, which, in the desert, is almost always visible. Indeed, it follows you, as if offering itself as a companion. Yet no matter how quickly one darts about or the commotion one raises, you will never be allowed to draw any closer. It is like an elusive, beautiful lover, tricked far too many times into love with false promises, then forgotten when the thrill has been had. Death haunts us in much the same way as does the horizon line, except that, in the end, it will engage us with one final embrace for all eternity.

 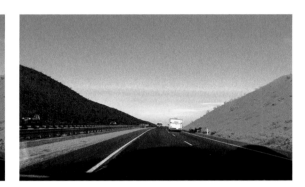

LIST OF PHOTOGRAPHS

13 Albert Camus, *The Myth of Sisyphus and other Essays*, translated by Justin O'Brien (New York, NY: Alfred A. Knopf, 1955); *The Myth of Sisyphus* was originally published in French as *Le Mythe de Sisyphe* (Paris, France: Gallimard, 1942).

16 *Midnight Cowboy*, directed by John Schlesinger (Metro-Goldwyn-Mayer, 1969); and L. Frank Baum, *The Wonderful Wizard of Oz* (Chicago, IL: George M. Hill, 1900); *The Wizard of Oz*, directed by Victor Fleming (Metro-Goldwyn-Mayer, 1939).

133 Lao Tzu, *Tao Te Ching*, translated by John C. H. Wu (New York, NY: Shambhala Publications, 2006), 1.

134 Frederic Nietzsche, *Twilight of the Idols*, translated by Walter Kaufman, in Walter Kaufman, ed., *The Portable Nietzsche* (New York, NY: Penguin Books, 1976), 468; *Twilight of the Idols* was originally published in German as *Götzen-Dämmerung* (Leipzig, Germany: C. G. Neeneer, 1889).

139 Clarence Darrow, as quoted in Irving Stone, *Clarence Darrow for the Defense* (New York, NY: Doubleday, 1941), 75

140 *The Ten Commandments*, produced, directed, and narrated by Cecil B. DeMille (Paramount Pictures, 1956).

144 William Blake, *The Marriage of Heaven and Hell*, *The Voice of the Devil*, Plate 9, line 46, from David V. Erdman, ed., *The Complete Poetry and Prose of William Blake* (Berkeley: University of California Press, 1982).

145 William Faulkner, *Requiem for a Nun* (New York, NY: Random House, 1951), 92.

149 *Born under a Bad Sign*, lyrics by William Bell, sung by Albert King, and released by Stax Records, 1967. The unattributed quote "Whoever you are . . ." comes from Tennessee Williams, *A Streetcar Named Desire* (New York, NY: Signet 1947), 142. The film adaptation of the play was directed by Elie Kazan and released in 1951 by Warner Brothers.

157 Robert Johnson, *Me and the Devil Blues*, originally recorded in 1937; released on *Genius of the Blues: Robert Johnson. The Complete Recordings* (Soul Jam Records, 2015); and Terry Southern, as quoted in Garin Pirnia, "13 Fast Facts about Easy Rider" (March 18, 2016), *Mental Floss*; http://mentalfloss.com/article/77348/13-fast-facts-about-easy-rider.

161 Victor Hugo, *Intellectual Autobiography* (New York, NY: Funk and Wagnalls, 1907), 287; and Paul Gaugin, *Vision after the Sermon (Jacob Wrestling with the Angel)*, oil on canvas, 28.4" x 35.8" (1888), in the collection of the National Gallery of Scotland.

164 The biblical translations for Genesis 2:17 and John 3:16 come from htpps://kingjamesbibleonline.org.

167 Buddhist proverb, variously attributed; according to the Website, fakebuddhaquotes.com, this proverb is likely of theosophical origin, attributed to Mabel Collins, *Light on the Path*, Third Edition (Boston, MA: Cupples, Upham, and Co., 1886), 48; and Kurt Vonnegut, *Slaughterhouse Five* (New York, NY: Delacorte, 1969).

172 *Harvey*, directed by Henry Koster (Universal Pictures, 1950).

173 William Blake, *The Voice of the Devil*, Plate 5, line 1, in Erdman, op cit. (as presented in 144).

178 Jimi Hendrix, "Hear My Train a Comin'," from the album, *Jimi Hendrix: Blues*, distributed by Sony Music Entertainment, 2014.

179 Epicurus, *Letters to Menoeceus*, translated by Drew Hicks in "Stoic and Epicurean" (New York, NY: Charles Scribner's Sons, 1910), 169.

182–83 Lucretius, *On the Nature of Things*, translated by A. E. Stalling (London, UK: Penguin, 2007), 11; originally written in Latin as *De Rerum Natura* (ca. 50 BCE).

SUGGESTED READINGS, VIEWINGS, AND RECORDINGS

Books

Carlos Castenada, *The Teachings of Don Juan: A Yaqui Way of Knowledge* (New York, NY: Simon and Schuster, 1973).

William deBuys and Joan Myers, *Salt Dreams: Land and Water in Low-Down California* (Albuquerque: University of New Mexico Press, 1999).

Zane Grey, *Wanderer of the Wasteland* (New York, NY: Harper's, 1923).

George Keenan, *The Salton Sea: An Account of Harriman's Fight with the Colorado River* (New York, NY: Macmillan, 1917).

Kim Stringfellow, *Greetings from the Salton Sea: Folly and Intervention in the Southern California Landscape, 1905–2005* (Santa Fe, NM: Center for American Places, 2005).

Films

Bagdad Café, directed by Percy Adlon (Pelemele Film, 1987)

Bombay Beach, directed by Alma Har'el (Focus World, 2011).

Paris, Texas, directed by Wem Wenders (Janus Films, 1984).

Past Pleasures at the Salton Sea, directed by Chris Metzler and Jeff Springer (Tilapia Film, 2009).

Plagues and Pleasures from the Salton Sea / Ghosts from Working Man's Death (Ironweed Film Club, Vol. 21, 2006).

Recordings

U2, *The Joshua Tree* (1987).

Sheryl Crow, "Leaving Las Vegas," on *Sheryl Crow and Friends: Live from Central Park* (1999).

The Eagles, *Hotel California* (1976).

Lane Hardin, *California Desert Blues* (1935).

Robert Plant, "29 Palms," on *Fate of Nations* (1993).

Nat King Cole Trio, "(Get Your Kicks On) Route 66," written by Bobby Troup (1946).

ACKNOWLEDGMENTS

I feel so much gratitude to those in my life who have helped shape this book. I truly could not have done it without them. Thanks to Will Crocker, Jack Leustig, and Perry Penick, for their creative input and belief in my work. Thanks as well to Kimberly Lavigne and Mary Stock, each trusted colleagues who reviewed earlier versions of the manuscript and offered invaluable comments, and to Lisa Gulledge, my administrative assistant and "auxiliary brain." Words cannot express my gratitude to David Skolkin, who served as the "quarterback" for the project, and to the amazing person to whom he introduced me, Mary Wachs. Her influence and guidance as the book's editor was indispensable. Thank you as well to George F. Thompson, my publisher, for recognizing the project as something potentially of interest to a general audience and for providing insightful editorial direction and ongoing refinement after receiving the baton from Mary. I also acknowledge the role of my daughter, Dominique, and my wife, Kathleen, not only for their creative contributions, but their unflagging love and support. Most of all, it is our love for each other that is the joy which made this effort necessary.

Finally, I thank the wonderful people who have entrusted me to be their physician over the years. Please know that I have always considered this to be a privilege for many reasons, among them being the reality that, even as I am your doctor, I, too, have been your student. This book would have been impossible without your grace and wisdom and the daily affirmation provided by you of the resilience of the human spirit when challenged.

James G. Barbee was born in New Orleans, Louisiana, but most of his childhood years were spent in the small town of Columbia, Mississippi, where he graduated as high school valedictorian. He then attended the University of Miami and formally graduated in 1975 with a double major in biology and chemistry. In 1974, he entered the Tulane School of Medicine in New Orleans. Upon graduation, he completed his first year of residency training in psychiatry at the Washington University School of Medicine in St. Louis and then served three more years to complete his residency at the University of California, San Diego. He then accepted a position at the LSU Health Sciences Center (LSUHSC) in New Orleans, where he remained for twenty-seven years and obtained the academic rank of Professor of Psychiatry, Pharmacology, and Neurosciences and was named the George C. Dunn Professor of Psychiatry. In 2009, he entered private pratice in New Orleans but remains a Clinical Professor of Psychiatry at LSUHSC and the Tulane University School of Medicine. He has consistently been named in *Best Doctors of America* since 2000. Barbee has lectured extensively at local, state, and national levels and has authored or coauthored more than thirty articles in professional journals, including *The American Journal of Psychiatry*, *The Journal of Affective Disorders*, *The Journal of Clinical Psychopharmacology*, and *The Journal of Clinical Psychiatry*. He is a member of the American College of Psychiatry and in 1999 was named a Fellow of the American Psychiatric Association. Barbee has also been an active photographer for many years. In 2014, he was a finalist in the Blue Library Competition sponsored by PhotoNOLA and in 2015 was accepted as a finalist in TIPS 24: The International Competition, sponsored by the Texas Photographic Society. He currently resides in New Orleans with his wife, Kathleen, and they consider Taos, New Mexico, their second home, where they maintain a residence.

Jack Leustig was born and raised in farm country east of Cleveland, Ohio. He began his professional career as a photographer during the early 1970s working for United Press International in New York City. During the 1980s and 1990s, he worked in the film industry and collaborated on many major films, including "500 Nations," the eight-hour prime-time documentary mini-series for CBS, which he wrote, produced, and directed. In 1996, he was honored with the National Endowment for the Arts Award for the Advancement of Learning through Broadcasting. In 2002, Jack Leustig Imaging (now Fine Art New Mexico) opened in Arroyo Seco, New Mexico, and immediately emerged as a leader in the highest-quality printing of photography and fine art.

ABOUT THE BOOK AND THE CRAFT

Sin Sombras/Without Shadows: A Search for the Meaning of Life, if There Is One, in the California Desert in Photographs and Stories was brought to publication in an edition of 1,000 hardcover copies. The text was set in Joanna MT, the paper is GardaMatt Art, 150 gsm weight, and the book was professionally printed and bound by Editoriale Bortolazzi-Stei in Verona, Italy.

 Publisher: George F. Thompson
 Manuscript Editor: Mary Wachs
 Editorial and Research Assistant: Mikki Soroczak
 Proofreader: Purna Makaram
 Book Design and Production: David Skolkin

Most of the photographs in this book were taken with a Canon EOS 5D Mark III camera, equipped with either a Canon 16-35mm f2.8L III USM or a Canon EF 24-70mm/f2.8L II USM zoom lens. The panoramic images were shot with an Apple iPhone 6. All of the images were downloaded on a computer utilizing Adobe Lightroom software. They were then reworked, using the creative controls available in the Adobe Lightroom and Photoshop programs. All of the book's original prints were made on equipment provided by Jack Leustig Imaging, L.L.C. (now Fine Art New Mexico).

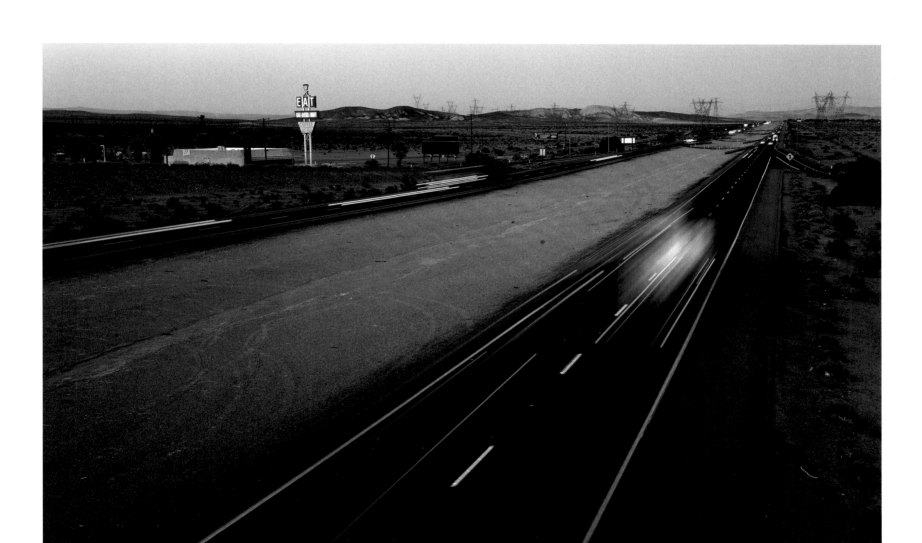

Published 2018. First hardcover edition.
Printed in Italy on acid-free paper.

George F. Thompson Publishing, L.L.C.
217 Oak Ridge Circle
Staunton, VA 24401-3511, U.S.A.
www. gftbooks.com

26 25 24 23 22 21 20 19 18 1 2 3 4 5

The Library of Congress Preassigned Control Number is 2017957727.

ISBN: 978–1–938086–58–8